W9-AHH-653

The Lost
Artwork of

Hollywood

Classic Images
from Cinema's
Golden Age

The Lost Artwork of

Hollywood

Fred E. Basten

Foreword by Ted Sennett

Watson-Guptill Publications/New York

Editor: Micaela Porta
Designer: Wynne Patterson
Production Manager: Ellen Greene

Copyright © 1996 by Fred E. Basten

First published in 1996 by Watson-Guptill Publications,
a division of BPI Communications, Inc.,
1515 Broadway, New York, NY 10036.

Library of Congress Cataloging-in-Publication Data

The lost artwork of Hollywood:
classic images from cinema's golden age/ [compiled by] Fred E. Basten.
p. cm.
Includes bibliographical references and index.
ISBN 0-8230-8345-4
1. Motion picture actors and actresses—United States—Portraits.
2. Film posters. 3. Advertising—Motion pictures. 4. Art, Modern—20th
century—United States. I. Basten, Fred E.
PN1998.2.L68 1996
791.4330283092273—dc20 96-17873
 CIP

Distributed in the United Kingdom, Eastern
Europe, Russia, and the Middle East by Windsor
Books International, The Boundary, Wheatley
Road, Garsington, Oxford OX44 9EJ, England.

Distributed in Western Europe (except the United
Kingdom), South and Central America, the
Caribbean, and Asia (except the P.R. of China) by
Rotovision S.A., Route Suisse 9, CH-1295 Mies,
Switzerland.

Distributed in Canada by General Publishing,
30 Leesmill Road, Don Mills, Ontario M3B 2T6,
Canada.

All rights reserved. No part of this publication
may be reproduced or used in any form or by any
means—graphic, electronic, or mechanical, includ-
ing photocopying, recording, taping, or information
storage and retrieval systems—without written per-
mission of the publisher.

Manufactured in Italy.

First printing, 1996

1 2 3 4 5 6 7 8 9 /02 01 00 99 98 97 96

This book is dedicated to the unheralded illustrators,

portraitists, caricaturists, cartoonists, and graphic artists

who worked behind the scenes to create promotional visuals

that drew us into the fantasy world that is the movies.

Contents

Foreword by Ted Sennett 10

Preface 12

Part 1: The Early Years 15

Part 2: The Thirties 43

Part 3: The Forties 109

Part 4: From the Golden Age to Today 163

Part 5: The Artists 173

Bibliography 185

Index 187

Acknowledgments

The author wishes to thank the following individuals for their invaluable assistance and cooperation:

Maureen D. Angelinetta, Sherry Angle, Joe Blackstock, Rod Dyer, E.A. Eldred, John Elvin, Ronald Haver, Wayne Holliwell, Tom A. Jones, Eugene Kaufman, Paul Lukas, Ken Markman, K.F. Matthews, "Mickie" Meade, Ronald L. Perkins, Marc Pevers, Matthew Rafani, Tom Seehof, Ted Sennett, Judith Singer, Sheldon H. Sroloff, and Ren Wicks

I am also grateful to the many organizations that authorized use of the promotional artwork shown in this book, reproduced courtesy of:

Columbia Pictures Industries. All rights reserved.
The Walt Disney Company. All rights reserved.
The Samuel Goldwyn Company. All rights reserved.
Metro-Goldwyn-Mayer, Inc. All rights reserved.
The Rank Organization. All rights reserved.
Twentieth Century-Fox Film Corp. All rights reserved.
United Artists Pictures. All rights reserved.
Universal Pictures, a division of Universal City Studios, Inc. All rights reserved.
Foster & Kleiser
Pacific Outdoor
Pacific Title

Foreword

Once upon a time, only a few decades ago, going to the movies was a joyful communal experience. Joined by your friends and armed with bags of peanuts and Good 'N Plenty, you barrelled into the local bijou, eagerly anticipating the pleasure of seeing your favorite stars in action. Back in the thirties and forties, there were no tenplexes, no wide screens—just you and your pals in the darkness having a royal good time.

For those who made the movies of that golden era, getting them into the theaters where they could be seen at their best was, of course, a grueling and competitive business. But it could also be exhilarating—there was the challenge of bringing these movies to the attention of the men and women who owned the theaters and exhibited the films. To attract the interest of these important people, the studios needed to place splashy, eye-catching ads in such trade publications as *Hollywood Reporter, Daily Variety,* and *Motion Picture Daily.* To do this, they drew on the talents of some of the best commercial artists and illustrators of the day. The result was a long series of exceptionally beautiful full-page advertisements (many in radiant color) that captured the essence of the movies on display. For many years, these advertisements have remained lost and unseen, glorious reminders of a vanished time in the world of entertainment.

Happily, they are lost no longer. Through the loving care of their champion, Fred E. Basten, the best of them have now been restored in this invaluable book. These classic images are now ours to enjoy again.

I have scanned these images with delight and surprise, marveling at the artistic skill, the wit, and the attention to detail that can be found in all of them. There is, for example, the work of art director Herbert Jaedicker and his team at United Artists in the late thirties: the

glowing watercolors of the ad for *Vogues of 1938* or the exquisite Oriental motif for *The Adventures of Marco Polo*. And yet color is not always required—one need only look at the beautiful black-and-white rendition of stars Ingrid Bergman and Leslie Howard in John LaGatta's illustration for *Intermezzo*.

With "more stars than there are in heaven," Metro-Goldwyn-Mayer led the way in glamour and glitter, and Fred Basten's book gives us a generous look at the publicity—or what used to be called *hoopla*—for their biggest movies. In the early forties, artist Jacques Kapralik seems to have been prominent at the studio, creating stunning advertisements for such MGM films as *Random Harvest* and *Woman of the Year*. (The latter is my personal favorite of his drawings—see how it crystalizes the movie's charm and wit.) Even a minor movie like *We Were Dancing* gets the Kapralik treatment with its lush brocade, gold foil, and silver stars.

Perhaps best of all, this book restores the lost work of some of the most renowned illustrators of the period, such as Al Hirschfeld and Alberto Vargas. Hirschfeld's wonderful drawing of a scene from *Meet Me in St. Louis* can be cherished as a permanent reminder of that enchanting musical, while Vargas created his own view of the forties pinup sweetheart, Betty Grable. Even the celebrated Norman Rockwell was prevailed upon to create posters for such prestigious Fox movies as *The Razor's Edge* and *The Song of Bernadette*. Rockwell's contributions to several campaigns, along with the work of many other gifted artists, are recreated in this book.

I, for one, am delighted to know that these posters and advertisements have been rescued from the dustbins of movie history and brought back for all of us to enjoy and appreciate. Thanks, Fred.

Ted Sennett
Closter, New Jersey
March 1996

Preface

In the spring of 1983, I contacted Ron Haver about an idea for a new book to be called *Art of the Movies*. It was my hope to have Ron work with me on the book. As Director of Film Programs at the Los Angeles County Museum of Art, he seemed like the perfect choice. He had established the museum's film department and programs, which are considered among the finest in the world.

"Art of the Movies," he said, repeating the only solid bit of information I had told him about the project. "How can I help?"

Ron was basing his offer solely on the title and his love of films. To make sure he understood, I described the subject more fully. "It's not about the art of making movies. It's about illustration and graphics, real art drawn to promote films."

"A book of movie ads? That's been done before."

"But these visuals weren't created for the public. They were done by the studios for the trades to excite exhibitors and get them to show their movies. This art has been buried for fifty to sixty years."

Ron perked up again. "Hollywood's lost art," he said. "I love the concept."

Ron and I had met three years earlier. We both had books published that year of 1980. His was *David O. Selznick's Hollywood,* mine was *Glorious Technicolor: The Movies' Magic Rainbow.* We had talked on the phone periodically since that initial meeting, but we had seen each other only once. Knowing my involvement with Technicolor, he had invited me to a special screening at the museum of a newly restored print of *Becky Sharp* (1935), the first feature film in Technicolor's full-color process.

When I phoned Ron in early 1983 he had a lot going on. Aside from his responsibilities at the museum, he was working on the restoration of Judy Garland's film *A Star Is Born,* tracking down and

adding much of the missing footage that had been cut from the original 1954 release. Even so, he was generous with his time and expressed real interest in my new venture and his willingness to be a part of it. I had been gathering and researching material for several years prior to our conversation. Nevertheless, I still had work to do, so I said I'd get back to him as soon as possible.

It took longer than I thought. There were changes in format and more searching to be done, along with deadlines on other book projects that took precedence. Still, we talked from time to time. As busy as he was, and at one point he had a new book of his own in production (*A Star Is Born: The Making of the 1954 Movie and Its Restoration*), his first words were always, "How's the book coming?" If I had questions, he'd offer guidance, and even though it seemed I was forever apologizing for the delays, he never failed to say, "Just let me know when you want me to get started."

I waited too long. In April of 1993, I learned that Ron was ill. A month later, he was gone.

Ron Haver never saw the finished manuscript for the renamed *The Lost Artwork of Hollywood,* but his enthusiasm and love of the movies fill its pages.

<div align="right">

Fred E. Basten
Santa Monica, California
March 1996

</div>

Part One

The Early Years

*I*t began with pictures, crude drawings scratched into the earth and onto cave walls; images painted on rocks, utensils, and vessels; curious signs and symbols smeared across the faces and bodies of young warriors and chieftains. Drawings and images stood in place of letters. Those pictures from long ago may not have been worth a thousand words, but they came close. In their simplicity there was great strength. They displayed emotion, ritual, action, nature, and environment—an undeniable sense of the times. They told a story.

Communication has come a long way since the dawn of history. Not only have materials, methods, and styles changed, but people have changed. Yet the desired result is still the same: to show, to tell, to record, to illuminate through illustration. Through the years the artwork of the movies—from billboards and posters to magazines and newspaper displays—has evolved into an art form all its own. Collectors as well as merchants admit that the most valued material (and much is rare and highly prized today) is seldom gauged by a film's historic importance or even star association. The best criterion is its artistic merit. On that alone, there exists a wealth of glorious treasures.

The artwork of the movies was yet to come when Thomas Alva Edison shot the first successful motion picture film in 1889. Since Edison saw no future in images projected on a screen (he regarded his invention as a toy), he was content to develop a box-shaped machine that allowed viewers, one at a time, to see the moving pictures through a small eyepiece in the top. Edison stubbornly held to his beliefs, even against the urgings of associates who felt the images should be projected so that groups could view them at a single showing. He was not, however, against making his invention, which he called the Kinetoscope, available to interested parties on a royalty basis.

By the mid-1890s, peep show parlors lined with rows of Edison's Kinetoscopes were attracting large numbers of patrons eager to wit-

ness such mini-epics as *The Widow Jones,* considered the first shocker because of its sequence containing a prolonged kiss. But that was tame compared to much of the titillating subject matter coming into view.

The success of Edison's invention spawned numerous imitators and rivals. In 1894 Woodville Latham perfected a machine similar to Edison's with one advantage: Latham's creation could project pictures onto a small screen. The debut of the first projected motion picture, a prize fight specially staged on the roof of New York's Madison Square Garden, was held on May 20, 1895.

Even in these early formative years of moving pictures, filmmakers and nickelodeon operators were aware of the importance of promoting their product. And while the novelty of the new entertainment was enough to attract the curious, it was necessary to inform the public of changes in programming and viewing locations. In many areas, however, newspapers ignored the movies until exhibitors began to run paid advertisements. Even then, periodicals carried the simplest of announcements, usually small listings without art or illustrations. These announcements, like want ads, consisted solely of typeset information. A typical newspaper ad read: *THE RIALTO: Where you see the new and high-class pictures first. Program changed four times a week. Admission 5 cents.* Larger display pieces such as handbills, window cards, and posters carried much the same all-type information, and were widely distributed in concentrated areas.

Although a number of landmark films were released in the following years, including *A Trip to the Moon* (1902), *The Great Train Robbery* (1903), and *The Eagle's Nest* (1907), it wasn't until 1910 that names of performing players were listed, even in a film's credits. Anonymity was the rule, partly to standardize the business of filmmaking as much as possible, and partly to hold down costs. The prevailing belief was that once players gained recognition and fame their salaries would skyrocket.

The culprit behind the no-name policy was the General Film Company, better known as "the trust." Made up of the leading American firms (Biograph, Vitagraph, Essanay, Kalem, Selig, Klein, and Lubin) and two major French concerns (Pathé and Melies), the trust controlled the wholesaling and retailing of pictures. The trust's refusal to release the names of its players infuriated nickelodeon fans, who waged letter-writing campaigns demanding the identities of their favorites. The unanswered inquiries prompted ticket buyers to take matters into their own hands by christening the players with such nicknames as "The Biograph Girl" and "the little girl with the golden curls."

The change came when a renegade independent exhibitor-turned-distributor, Carl Laemmle, ran a large advertisement in *Moving Picture World* boldly headlined, "We Nail a Lie." The ad was supposedly placed to refute a newspaper story that had Florence Lawrence, the popular "Biograph Girl," killed by a streetcar. "Miss Lawrence was not even in a streetcar accident," the ad stated, "[she] is in the best of health." The shocking "death" of Florence Lawrence was actually a hoax concocted by Laemmle himself to dramatize the fact that he had lured the movies' then most famous leading lady away from her former employer to his own Independent Motion Picture Company of America (IMP). Laemmle took full advantage of the advertising space to announce not only that the one-time Biograph Girl had become the IMP Girl, but that she would be appearing in her first IMP picture, *The Broken Bath*. Thanks to Carl Laemmle's unorthodox promotional scheme, Florence Lawrence became the first film star to be known to the public by name.

The other independents wasted little time in capitalizing on Laemmle's coup by disclosing the names of their own players, forcing the trust to reverse its policy. Soon movie advertisements began introducing audiences to such performers as Clara Kimball Young, John Bunny, Maurice Costello, Hobart Bosworth, Betty Compson,

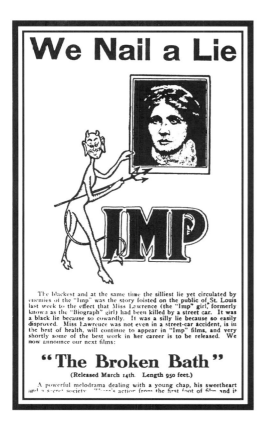

The ad that rocked an industry. Carl Laemmle's follow-up to his planted newspaper story telling of the "death" of Florence Lawrence, the "IMP Girl," brought the actress newfound fame and recognition as the first film star to be identified by name. The black-and-white ad, which appeared in 1910, consisted of crudely drawn line art combined with a flood-lit halftone portrait of the star.

Alice Joyce, Blanche Sweet, William Farnum, Francis X. Bushman, Pearl White, Marie Dressler, Lillian Gish, and "the little girl with the golden curls," Mary Pickford.

In 1914, *Motion Picture News* reported: "Motion picture manufacturers now realize that it takes more than a camera, a pint of Kodak experience, and an unbacked ambition to make films photographically good and salable. It takes advertising, and any student of advertising knows well that it is a science that can not succeed simply with parroted ideas and a superficial vocabulary of selling phrases." How much longer could moviemakers rely on simple display pieces and newspaper listings to announce their releases? Film, after all, was a product, one that offered entertainment, escape, an entirely unique experience. Such a product had to be merchandised and promoted with as much flair and creativity as any other specialty item.

By now it was becoming all too clear that the growing film industry had a big advantage over all other forms of entertainment. The movies had created their very own stable of stars. A star's name on

Desert Gold
Pathé, 1919

Elmo Lincoln made screen history, and a name for himself, when he appeared as the first Tarzan of the Apes in 1918. While he repeated the role in two feature films and a serial (all silent), he went on to play leads and supporting roles in a variety of films into the early 1950s, sometimes billed as "E.K. Lincoln." In *Desert Gold,* his twelfth feature film, Lincoln was cast true to type. His sturdy build and pleasing good looks made him a natural for outdoor dramas. To capture the atmosphere of the Zane Grey story, set in the old West, an uncredited artist transformed a black-and-white still from the film into color, using hand-tinting and overlays. The use of a single color, an orange-yellow suggested by the film's title, is surprisingly effective. In varying degrees of intensity, from strong to pale, it adds a warmth and richness to the sunset sky and landscape, even to the skin tones of the central players.

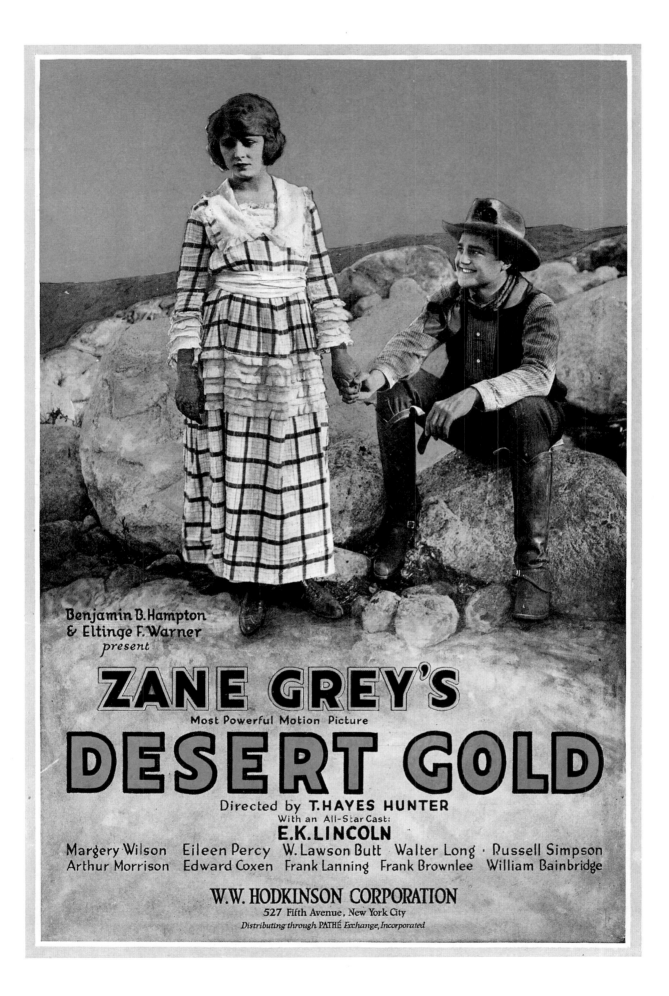

the screen elicited applause. A star's name on a marquee turned heads. It made sense, then, that a star's name—and image—featured in promotion would generate a new wave of enthusiasm and profits for all phases of the business.

Prior to World War I, magazines had been the greatest source of entertainment for the American public, providing not only quality writing but exceptional artwork and photographic illustrations (many in full color) through the pages of such popular titles as *Life, McCall's, Good Housekeeping, Collier's,* and *The Saturday Evening Post.* The artists whose work appeared in these publications were highly sought after. An illustration by Maxfield Parrish, J.C. Leyendecker, Edward Penfield, Norman Rockwell, or Howard Chandler Christy got attention. The artist's signature was a mark of prestige.

The fledgling motion picture industry could not compete with the giant publishers or their advertisers who offered lucrative contracts, often in five figures, for an artist's services. But the movies were fast becoming a glamour business. For many artists, like actors, movies held a certain allure—and an opportunity to display their creative talents. It was therefore not impossible to obtain promising as well as seasoned illustrators and designers who were willing to work without fanfare for lower wages.

The earliest attempts at motion picture advertising art were crude by artistic standards, often featuring poorly reproduced halftone photographs. Line art was considerably more successful, offering a sharper, cleaner image and permitting more flexibility in design. The trend to line art lasted well into the twenties. In an effort to be stylish, due in part to a dearth of available decorative typefaces, most headlines were hand lettered. Few were professional in appearance; the majority had an amateurish quality.

As film production companies expanded following the war and competition increased, motion picture art began to take on a new pro-

fessionalism. Color ads were not uncommon, though they appeared mainly in trade publications to tempt exhibitors. Color meant added expense, but this was an era of gilded mansions, Pierce-Arrow automobiles, and madcap parties. Money was in plentiful supply thanks to the new American royalty, stars such as Rudolph Valentino, Clara Bow, Douglas Fairbanks, Charlie Chaplin, and Gloria Swanson. No time in the history of movies was brighter or more wild.

While the techniques of the leading illustrators were certainly influential, they were not outwardly imitated. Still, there was no denying that advertising's ideal male figure was beginning to resemble Leyendecker's "Arrow Collar Man," or that flappers of the period embodied the spirit and character of John Held, Jr.'s flashy figures. Even Aubrey Beardsley, the decorative artist whose earlier work was experiencing a revival, had his loyal followers.

Of all the contemporary illustrators, Coles Phillips proved to be the most affecting. Enormously successful for his "Fadeaway Girls" (the "flat" design of his central figure was integrated with the basic color of the background), Phillips set the standard for the American ideal of young womanhood that was later refined by Alberto Vargas and George Petty. It is a concept that exists even today.

As the twenties drew to a close, marking more than forty years since the birth of motion pictures, two events had a profound effect on the film industry: the advent of talking pictures and the Great Depression. Ahead would come a period of drastic change—and the Golden Age of classic movies.

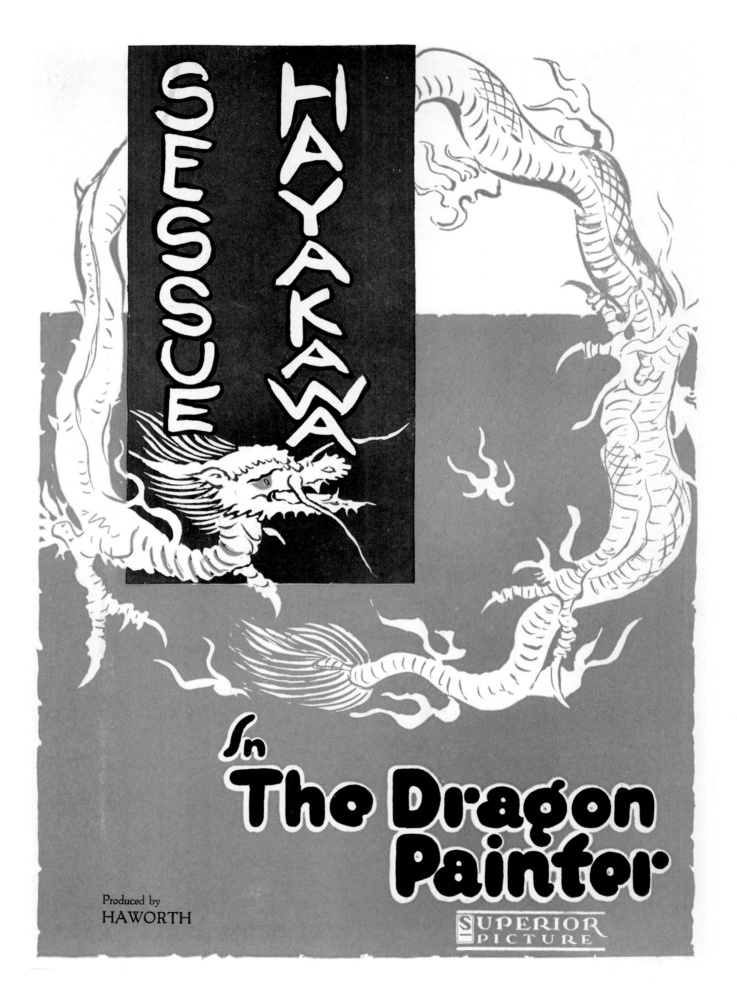

SESSUE HAYAKAWA

In **The Dragon Painter**

Produced by
HAWORTH

SUPERIOR
PICTURE

The Dragon Painter
Superior, 1919

Japanese-born Sessue Hayakawa's
long film career (he was Oscar-
nominated in 1957 for his role in
The Bridge on the River Kwai) began
shortly after his discovery in 1914
by pioneer filmmaker Thomas Ince.
Hayakawa's exotic appearance and
expressive personality quickly
brought him fame, as well as star
status. This early two-color exhibi-
tor ad, using a wood block tech-
nique, effectively conveyed a strong
thematic sense of the film, touted
to be "the last word in splendor
and beauty."

Mind the Paint Girl
Louis B. Mayer, 1919

This pen-and-ink drawing depicts the film's star, Anita Stewart, for
the promotion of "a drama of stage life." The round black area held
by the illustrated figure would later be filled with reverse type, list-
ing the star's name and film title. Also included were other credits,
including a tag line that read: *"Young men! Beware of the painted beau-
ties of the stage."*

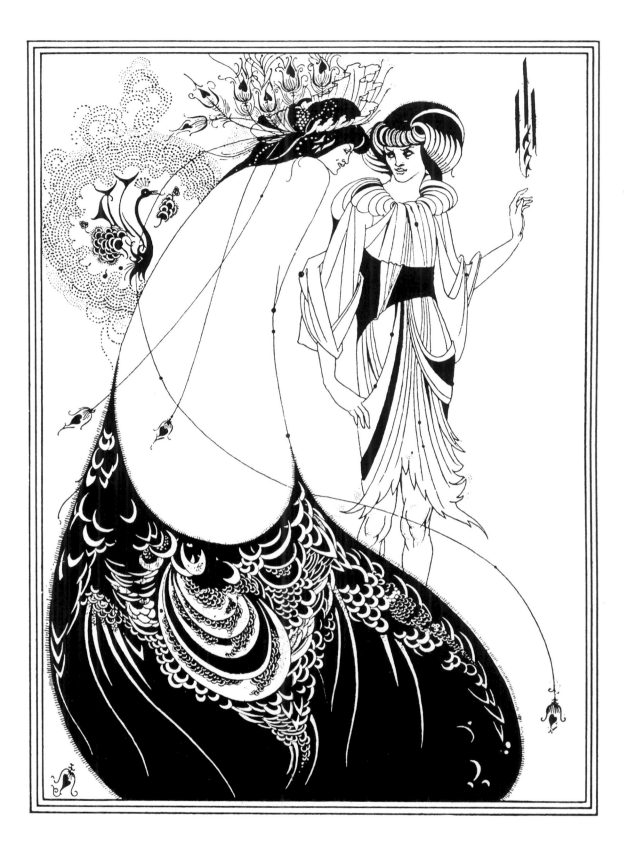

Part One: The Early Years

The work of both English illustrator Aubrey Beardsley (1872–1898) and American illustrator Coles Phillips (1880–1927) greatly influenced the promotional art of Hollywood's early-film era. Beardsley was an almost technically perfect draftsman who helped revolutionize English graphic art by his use of flat areas and white "cut-away" lines. He worked almost exclusively in pen and ink, black on white, to create a strange fantasy world that appeared freakish at times. His style was not always flattering to his subjects, who were often depicted as misshapen and grotesque, usually sensuous, and at times obscene. It was from studying Greek vases that Beardsley learned much of his use of dark areas contrasted with fluid lines. Unfortunately, his career was short lived. He produced furiously for only five years, and died of consumption at the age of twenty-six. Shown here is "The Peacock Skirt" from Beardsley's *Salome* designs.

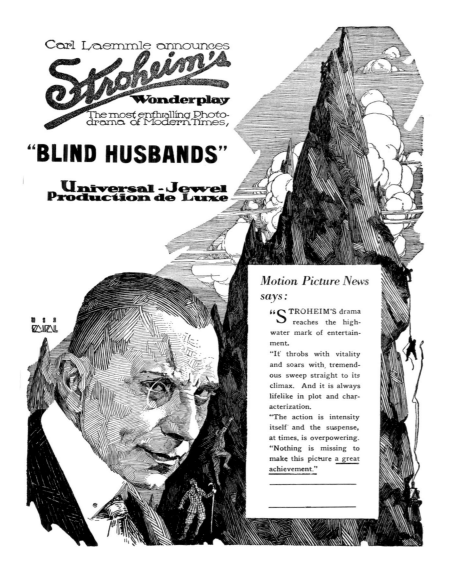

Carl Laemmle announces

Stroheim's

Wonderplay

The most enthralling Photo-drama of Modern Times,

"BLIND HUSBANDS"

Universal-Jewel Production de Luxe

Motion Picture News says:

"STROHEIM'S drama reaches the high-water mark of entertainment.

"It throbs with vitality and soars with tremendous sweep straight to its climax. And it is always lifelike in plot and characterization.

"The action is intensity itself and the suspense, at times, is overpowering.

"Nothing is missing to make this picture a great achievement."

Blind Husbands
Universal, 1919

This landmark silent film, cited for its meticulous attention to detail and psychological motivations, told of a sex triangle involving an Austrian officer on vacation in the Alps, and the wife of a rich American. It was an ambitious achievement for Erich von Stroheim, who not only starred in the film but directed, wrote the script (from his own short story, "The Pinnacle"), and designed the sets. The dramatic promotional art, intricately executed in a cross-hatch pen and ink drawing by artist Raiidall, shows a leering, monocled Stroheim (often billed as "the man you love to hate") against a soaring Alpine peak. The vertical block was used to hold interchangable reviewer quotes.

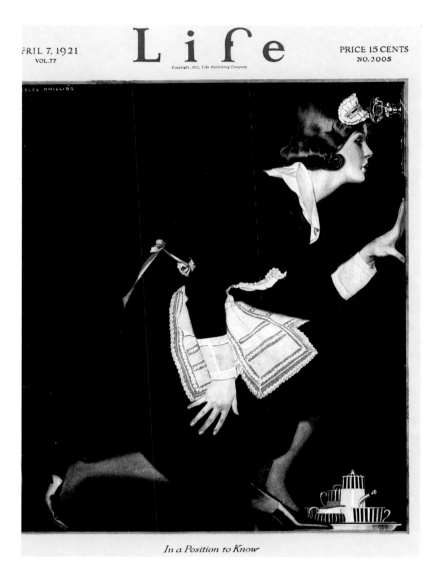

In a Position to Know

Long before George Petty and Alberto Vargas, there was Coles Phillips. His specialty was pretty girls, beautifully coifed and softly rendered, but he is especially remembered for his innovative series of drawings called the "Fadeaway Girl." The device was simplicity itself. Phillips placed the figure of a young woman against a background that became an integral part of the subject. Portions of her shape faded into the background, leaving the viewer to imagine where one ended and the other began. The Fadeaway Girl became enormously popular as she graced the covers of magazines. Phillips' illustrations were also in demand by major advertisers of the day, primarily by Holeproof Hosiery and Community Plate Silverware. This illustration, titled "In a Position to Know," graced the cover of the old *Life* magazine on April 7, 1921.

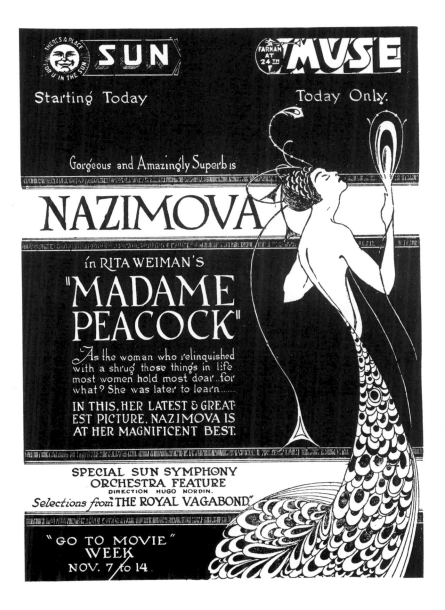

Madame Peacock
Independent, 1920

When Alla Nazimova, legendary star of the Russian and American stage, turned to acting in silent Hollywood films in 1916, her reputation as a highly stylized (and rather aloof) dramatic actress followed her. It is this image that an uncredited artist caught to portray Nazimova as the imperious Madame Peacock. The stark black-and-white pen-and-ink drawing boldly incorporates design elements from the Aubrey Beardsley school of art, including his famous peacock skirt.

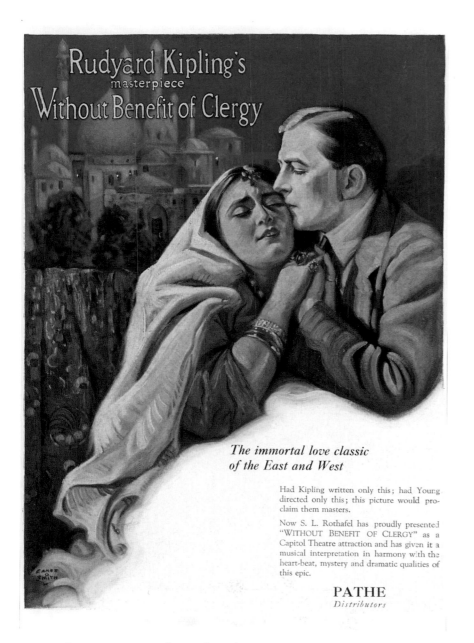

The immortal love classic
of the East and West

Had Kipling written only this; had Young directed only this; this picture would proclaim them masters.

Now S. L. Rothafel has proudly presented "WITHOUT BENEFIT OF CLERGY" as a Capitol Theatre attraction and has given it a musical interpretation in harmony with the heart-beat, mystery and dramatic qualities of this epic.

PATHE
Distributors

Without Benefit of Clergy
Pathé, 1921

Rudyard Kipling's passionate tale of temptation and forbidden love between East and West is illustrated in a melodramatic full-color oil painting by artist Emmett O. Smith. The rich, dark tones and shadowy lighting help dramatize the mysterious setting for the production, said to have been personally supervised by the author.

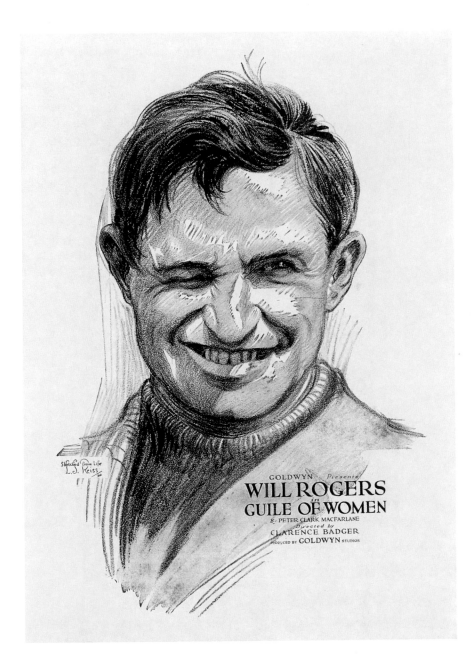

The Guile of Women
Goldwyn, 1921

A onetime performer in Wild West shows and a star with the Ziegfeld Follies, Will Rogers appeared in a number of silent films that failed to take full advantage of his homespun personality and biting satirical wit. With the coming of sound, however, he became a major box office attraction and spokesman of common folk everywhere. Here, in a pencil sketch by portraitist Lionel S. Reiss, the artist captures Rogers' puckish down-home charm for one of the showman's earliest releases.

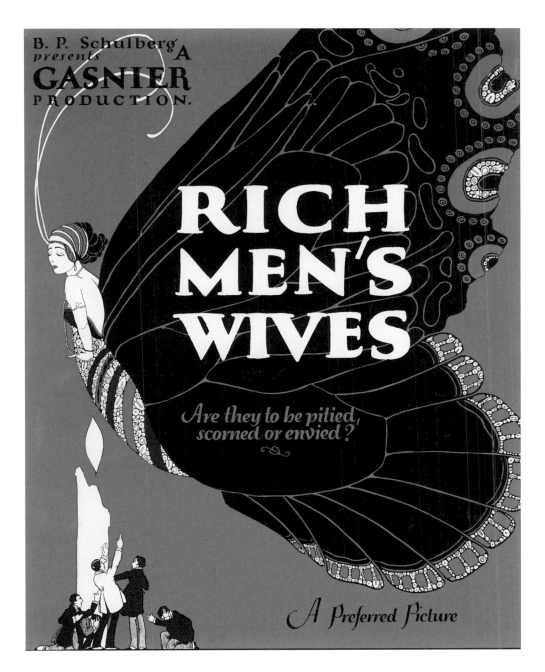

Rich Men's Wives
Preferred, 1922

Without a cast that included at least one famous name, the primary selling points of this feature rested on the storyline, settings, and intriguing title. The striking and rather sinfully decadent two-color poster design (complete with phallic symbol) by an uncredited artist is in the highly imaginative style of turn-of-the-century artist Aubrey Beardsley.

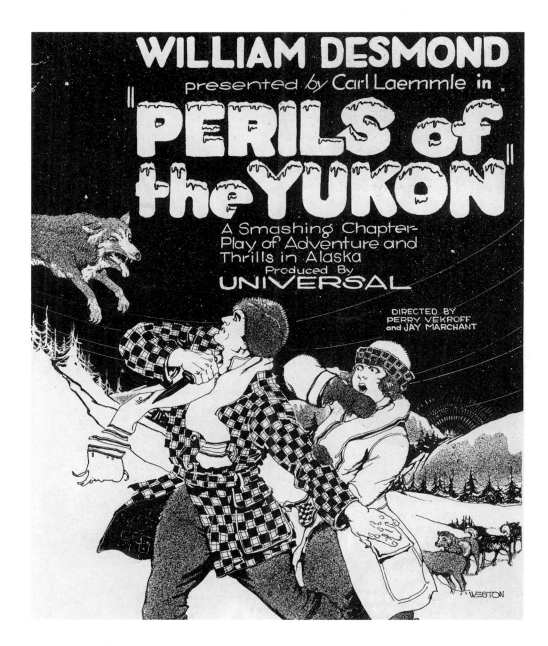

Perils of the Yukon
Universal, 1922

Handsome, muscular William Desmond entered films in 1915 play-
ing leading roles in society melodramas, but his greatest success
came in the early 1920s when he turned to rugged characters in
serials and action films. For the *Perils of the Yukon* adventure series,
artist Harry Alan Weston sketched the jut-jawed actor at a sus-
penseful moment, heroically protecting the "damsel in distress."
The element of danger is heightened by the blackened sky, which
also provides a dramatic backdrop for the credits set in reverse type.

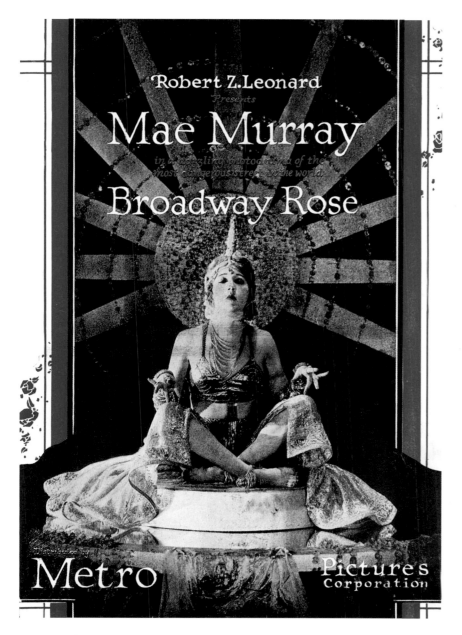

Broadway Rose
Metro, 1922

Mae Murray was a Broadway star at 21 as the dancing partner of Vernon Castle, then star of several editions of the "Ziegfeld Follies," which showcased Mae's dancing and singing. She achieved her greatest stardom, however, in silent movies. Blonde and beautiful, she became world-famous as "the girl with the bee-stung lips." This two-color trade ad for one of her best feature films combines posed studio photography with line art. The film's dark, mysterious mood is enhanced by Murray's exotic pose and costuming, set against a dimly lit jeweled sunburst.

The Thief of Bagdad
Fairbanks, 1924

Swashbuckling hero Douglas Fairbanks was the first film actor to play the wily thief who uses magic to outwit the evil Caliph in this special effects-filled fantasy. To promote his fanciful production, Fairbanks hired two poster artists: Adrian Gill Spear and Anton Grot. The Spear design, which focuses solely on Fairbanks, the star, is less effective in capturing the magical spirit of the film than the one by Grot (shown here). Grot's design illustrates the title character soaring across the storybook skies astride a flying horse. To achieve the desired color effect, Grot used the Pointillist technique invented by Georges Seurat, which combines small dots or points of contrasting color.

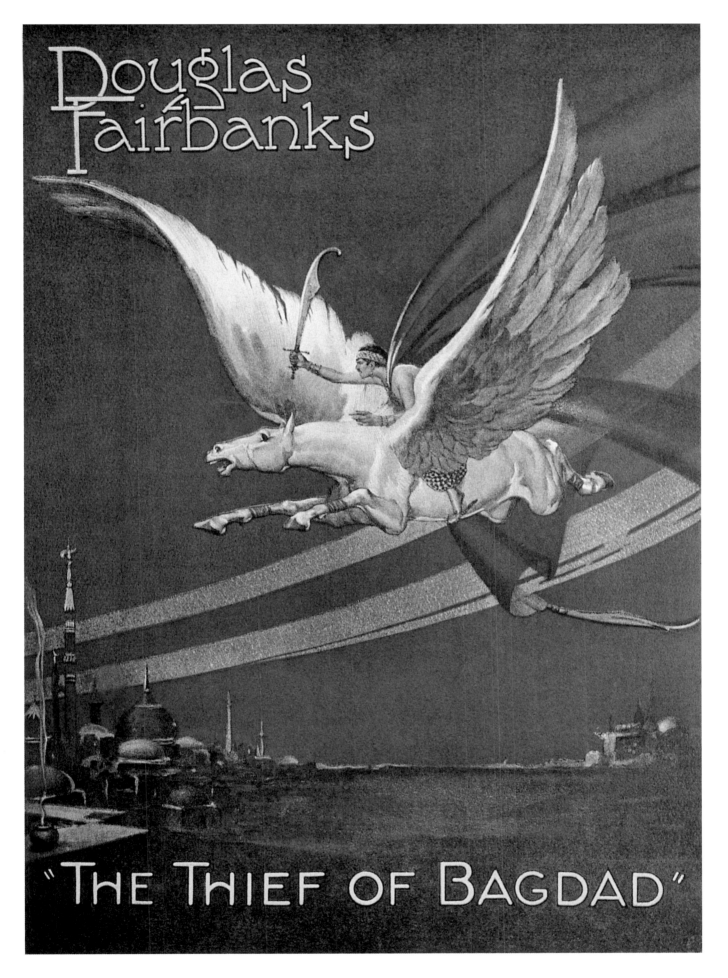

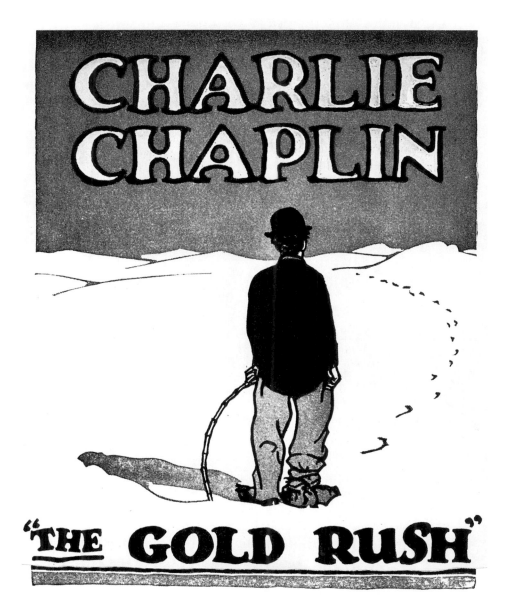

The Gold Rush
Chaplin, 1925

This simple black-and-white art, drawn in a cartoon style by an uncredited artist, effectively captures Charlie Chaplin's lovable pantomime character and the theme of the film: the Little Tramp pitted against the Yukon. One can almost feel the awesome task that lies ahead (or is it behind?) as Charlie the tramp gazes into the vast wilderness.

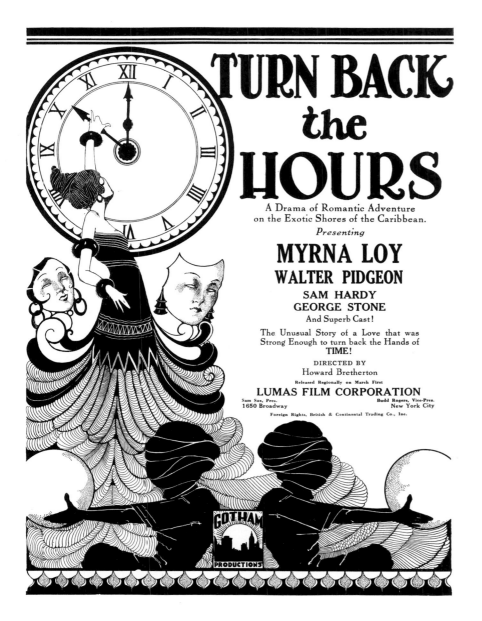

Turn Back the Hours
Gotham, 1928

For this drama of "a love that was strong enough to turn back the hands of time" set on the shores of the Caribbean, an uncredited artist incorporated various regional motifs. The decorative pen-and-ink drawing calls to mind the work of Aubrey Beardsley, without the sensuous overtones. It is unusual in that the film's romantic storyline, played out by stars Myrna Loy and Walter Pidgeon, is overlooked in the theme art.

Disraeli
Warner Bros., 1929

British actor George Arliss had appeared in *Disraeli* on Broadway before starring in the silent film version in 1921. Eight years later he again played the great Victorian statesman, this time in sound. The studio had two big pluses for its promotion: the acclaimed star and its heralded sound system. The uncredited artist brought these elements together in his crayon drawing, showing Arliss with "sound power" radiating from his head. Contrasting the primary art, drawn on a textured board, were seven simple line drawings (probably by another artist), illustrating Arliss in different scenes from the movie. The film was a *tour de force* for the star, who won the Oscar for Best Actor.

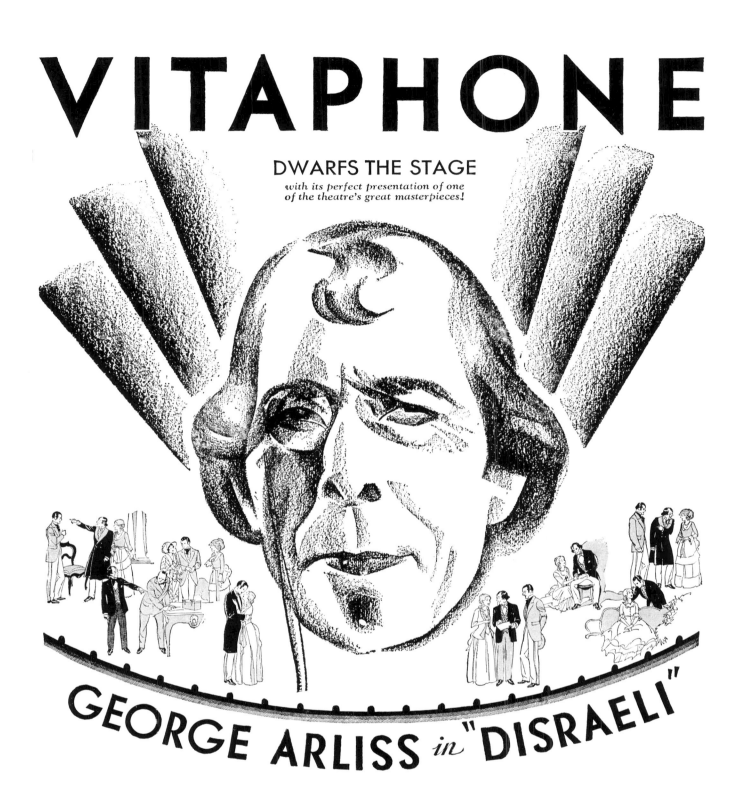

VITAPHONE

DWARFS THE STAGE

*with its perfect presentation of one
of the theatre's great masterpieces!*

GEORGE ARLISS *in* "DISRAELI"

Part Two
The Thirties

The unbridled enthusiasm that greeted the introduction of sound in film in the late twenties signaled the beginning of a new era in motion pictures. At least that was the assumption of studio heads who risked fortunes by halting production on key silent films already in progress, and rushing others of lesser quality into release. To convert their facilities for the revolutionary "talkies," studios built massive new sound stages, installed complicated new equipment, and hired audio experts. In the rush to climb aboard the sound bandwagon, little thought was given to story content or technique. Moviegoers wanted *sound*—and sound they would get.

It didn't take Hollywood long to discover that the best way to show off the good points of both film and sound was to specialize in movies that were impossible to make *without* sound. What could be more natural, then, than stories with songs? The new decade found the studios force-feeding the public backstage musicals—a genre that centered on characters involved in the theater—all of which had virtually the same plot. The few quality films—*All Quiet on the Western Front, The Big House, Anna Christie, Min and Bill, Little Caesar, Hell's Angels,* and *The Front Page*—could not outweigh the bad. Audiences soon grew weary of second-rate films accompanied by less than perfect or overused sound. Theater attendance slipped sharply; receipts for mid-1931 were the lowest in fifteen years.

Even with their give-aways and games staged between showings, motion picture theaters were hard pressed to attract business in the midst of the Great Depression's massive unemployment. The movies faced yet another challenge during these troubled times: radio. It had become far cheaper, and often more entertaining, to stay home and listen to sound without pictures.

Something had to be done. Studio art departments worked over-time to create not only compelling advertising but a quality image for their releases. Headlines became stronger, design concepts more refined, copy messages more analytical. Improvements in printing techniques that permitted better reproduction of black-and-white photographs led to the partial or even total replacement of pen-and-ink drawings by well-defined halftones of stars and scenes.

The improved quality of motion picture illustration reflected the eventual upgrading of product being offered. New themes were coming into release—mainly "escapist" vehicles to offset the troubled times—cast with new faces and new teams of players. When it became clear that many established stars of the silents could not make the transition to sound, the studios sought experienced "speaking" people from the Broadway stage. With the arrival of the New Yorkers, Hollywood took on a new sophistication and glamour.

As the movies began regaining their popularity, the studios grew and prospered, attracting the top creative talent available. The major studios had huge art departments staffed with specialists in their field. The departments' art directors had the artists work on assignments that best suited their talents. There were those who drew the best portraits of women, while others worked only on action scenes, spec-tacular panoramas, or Western backgrounds; some excelled at realism, while others had a lighter, more comedic touch. At times, big-name illustrators famous for their magazine work were called in. The work was constant and there were always deadlines to meet. Many studios released one film a week.

For the majority of people behind the scenes, working for the movies assured them a no-name existence. The artists on staff were

no exception. Although their work was often extraordinary, it was rarely credited. The fortunate few who did see their names in print—Cotton, Widhoff, Briggs, Birnbaum, LaGatta—were rare. Even Alberto Vargas' portraits of stars, scenic elevations, and occasional promotional illustrations for a number of studios including Warner Bros. and Twentieth Century-Fox went largely unsigned during the early and mid-1930s. Not until his days at *Esquire* magazine did he achieve the wide recognition his work still enjoys today.

Working in anonymity—a policy overcome by the performers in the early days of motion pictures—was adhered to by artists for good reason. Even space on posters, which were truly the artists' canvases, was limited. More importantly, the studios held to the belief that dominantly displaying an idea was infinitely more important than selling an artist's piece of work, especially one on salary. To a degree, this policy remains in effect today, although for different reasons.

In 1932, the Technicolor Corporation introduced its new full-color process in Walt Disney's animated cartoon *Flowers and Trees.* The color was impressive and added immeasurably to the success of the short subject, but the studios were hesitant to commit to color production for feature filming. Because earlier attempts at color had failed, they were content to simply sample the new color using sequences within black-and-white films. It was not until 1935 that the first full-color feature film, *Becky Sharp,* was released.

While color was slow to arrive on motion picture screens, it became increasingly popular in illustrations promoting the industry's products. Studios saw color as a major force in attracting attention to its features, particularly in publications where it dominated the page. Incredibly, full-color ads were used primarily to promote black-and-

white films. Metro-Goldwyn-Mayer, with its impressive roster of popular performers ("More stars than are in the heavens," the studio boasted), was the leader in innovative color illustration for its films, primarily in trade publications. Nevertheless, MGM was one of the most reluctant of the major studios to plunge into color cinematography on even a limited basis. *Gone With the Wind*, released in 1939, was only the studio's second venture into color feature filming. (*Sweethearts*, in 1938, was the first.) Even *The Wizard of Oz* (1939), despite its lingering impression of color, was considered to contain a lengthy color sequence within its bookended monochromatic portions.

In 1937, a compilation of ads that appeared during the year was published in a massive volume entitled *Advertising in the Motion Picture*. Crediting the contributors "who have grown up in and with the industry," the opening remarks noted that the imposing level of performance achieved "a high level which becomes extraordinarily manifest if one takes even the most casual comparison of the performance of other industries. It is probable that there is no other merchandising field in which the makers of advertising are so well integrated with their industry, and so intimately familiar with their wares or attuned to their buying audiences." Although the publication stopped short of calling the collective material importantly superior in its selling power to the best of the two previous decades, "it is emphatically to be noted that the average performance of today is tremendously more effective than in, say, 1917."

With renewed interest in films, the major studios were busier than ever. The pressure to coordinate advertising promotions geared for the various media was enormous. There were newspaper and magazine ads of various shapes and sizes, all incorporating theme art;

preliminary announcements and ongoing trade ads; posters; inserts; placards; lobby displays; and still other pieces. Outdoor billboards were becoming increasingly popular. Special billboards for Disney's *Snow White and the Seven Dwarfs* were so eye-catching that they were considered a traffic hazard and had to be replaced.

By the end of the thirties, the studio illustrators and graphic artists were experimenting with overlays and reverse printing techniques, bringing a new excitement and dimension to their creations. In just a few short years the artwork of the movies had advanced considerably, reflecting the revitalized art of filmmaking.

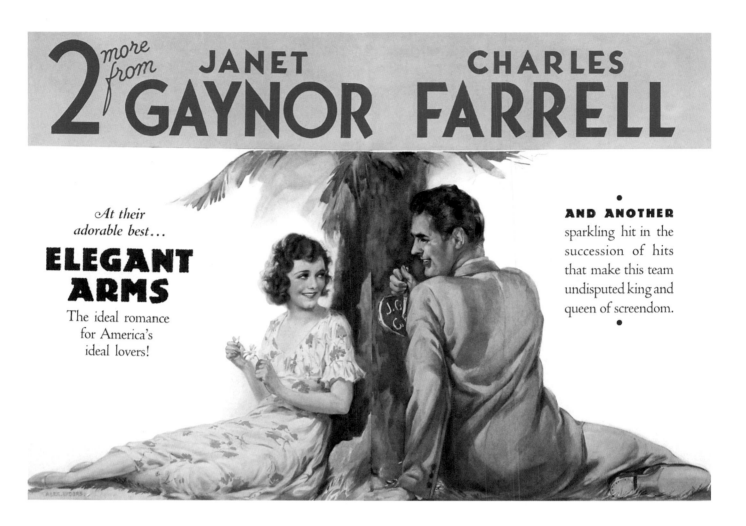

2 more from **JANET GAYNOR** **CHARLES FARRELL**

At their adorable best...

ELEGANT ARMS

The ideal romance for America's ideal lovers!

AND ANOTHER sparkling hit in the succession of hits that make this team undisputed king and queen of screendom.

The First Year
Fox, 1932

For the ninth screen teaming of Janet Gaynor and Charles Farrell, known as "America's favorite lovebirds," the studio mounted a special campaign to further endear the couple to the moviegoing public. The romantic watercolor by Alex Luders appears to be promoting more than a working relationship between the two popular stars, however, as Farrell's likeness carves their real-life initials into the tree trunk. This was originally published as part of a two-page spread.

Hat Check Girl
Fox, 1932

Coles Phillips, whose fade-away designs of curvaceous American women helped set the standard for others to follow, was the inspiration for this rendering by an uncredited studio artist of Depression-era society and "a miss who missed nothing." The stark black panel, containing the likeness of the film's stars, Peggy Shannon and John Boles, creates added interest when contrasted with the colorful nightlife scene.

HAT CHECK GIRL

● A miss who missed nothing. She knew everything, heard everything—but learned that silent lips paid the biggest dividends. Men and women of the night were pawns in the game she played. *A new slant on the wise women of the White Way.*

PEGGY SHANNON
JOHN BOLES · EL BRENDEL
ALEXANDER KIRKLAND
From Rian James' best-seller
Directed by JOHN FRANCIS DILLON

Today We Live
MGM, 1933

William Cotton kicked off a series of caricatures of MGM studio stars with his impression of the film's two top leads, Joan Crawford and Gary Cooper. (Celebrated caricaturists Abe Birnbaum, Albert Hirschfeld, and Jacques Kapralik also became major contributors to the series.) The storyline, co-written by William Faulkner, concerning an aristocratic English girl and her three lovers who find themselves together at the front during World War I, was totally ignored in favor of the growing appeal of Crawford and Cooper. *Today We Live* was filmed in black and white.

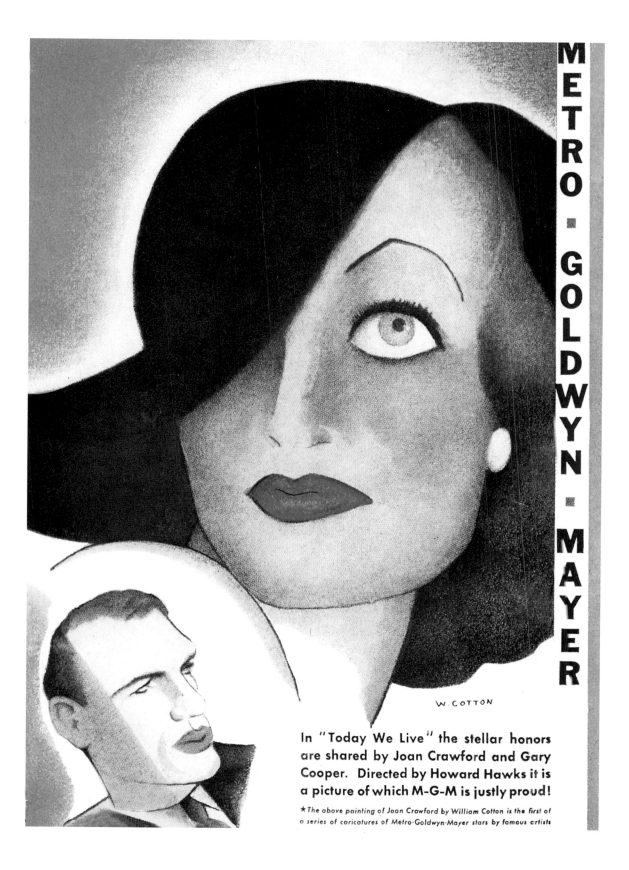

METRO · GOLDWYN · MAYER

W. COTTON

In "Today We Live" the stellar honors are shared by Joan Crawford and Gary Cooper. Directed by Howard Hawks it is a picture of which M-G-M is justly proud!

★The above painting of Joan Crawford by William Cotton is the first of a series of caricatures of Metro-Goldwyn-Mayer stars by famous artists

She Done Him Wrong
Paramount, 1933

Mae West's appearances on Broadway and in the movies had her continually running into censorship problems. Sex was the name of her game, and she flaunted it at every opportunity, either with her actions or in the dialogue she wrote and spoke. Although *She Done Him Wrong* was billed as "lusty entertainment," it was actually one of the least titillating of West's endeavors. Perhaps that is why she insisted on showcasing her ample assets to full advantage in promoting the film, which was based on her play, *Diamond Lil*.

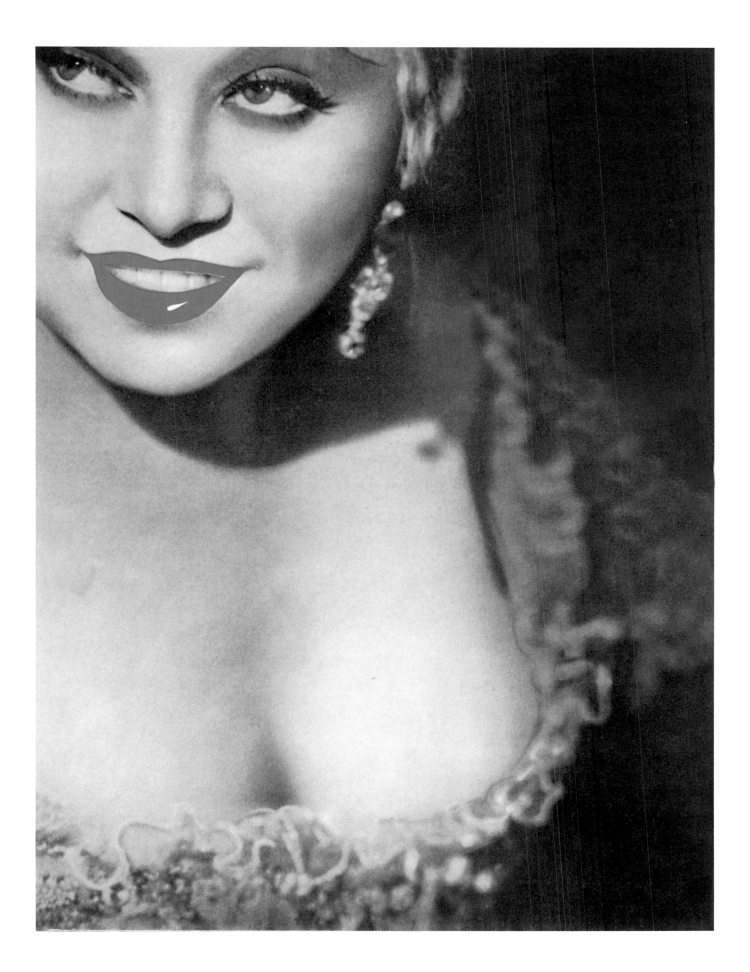

Day of Reckoning
MGM, 1933

During his years as a silent screen star, the words that best described actor Richard Dix were "strong" and "heroic." With the arrival of talkies, Dix continued to be cast in hard-hitting action/adventure dramas, and was nominated as Best Actor for his starring role as an Oklahoma homesteader in *Cimarron* (1931). As the quality of his films began to decline, so did his popularity. His image remained intact, however, as seen in the powerful graphics for *Day of Reckoning* by an uncredited artist, who combined industrial-style art of the period with a bold use of color.

RICHARD
DIX

THE STAR WHO HAS NEVER FAILED YOU!

Viva Villa!
MGM, 1934

The ongoing production problems that plagued the filming of *Viva Villa!* both in Mexico and in Hollywood—cast and directorial changes, countless retakes, a quickly escalating budget, threats from the Mexican government and Pancho Villa's widow, who claimed the storyline wrongly depicted her husband—had the studio brass jittery. Nerves calmed, however, with the film's release. Movie-goers swarmed to theaters in such numbers that *Viva Villa!* became one of the year's biggest draws. The main attraction was the rousing performance of gruff but lovable Wallace Beery as the revolutionary bandit. MGM played on Beery's popularity by using his full-blown image in its early promotion to motion picture exhibitors. This uncredited graphic is almost certainly the work of illustrator/cartoonist William Galbraith Crawford, whose loose, sketchy style and striking use of color was characteristic of numerous MGM posters from the mid-1920s through the 1940s. The reclining lady on the sombrero is King Kong's earlier love interest, Fay Wray.

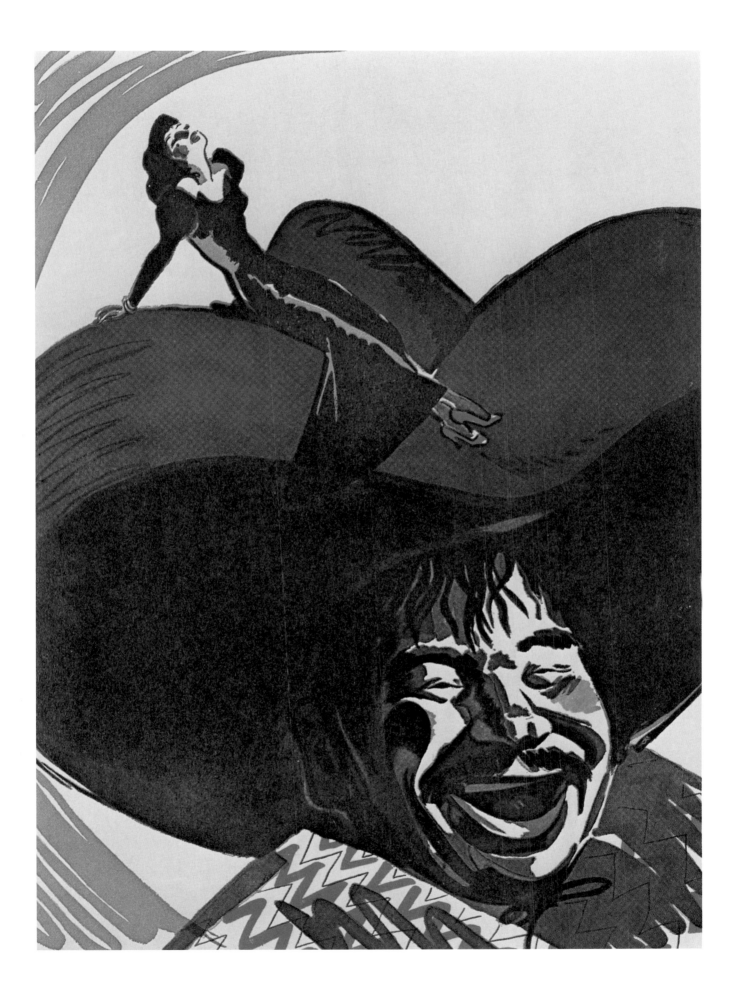

Reckless
MGM, 1935

Jean Harlow was such a major star that other stars—in this case, William Powell—were often sacrificed in favor of her image, or images. Here, under the guidance of art director Hal Burrows, Harlow appears three times in various poses. With the platinum blonde bombshell, two were generally a must, once to display her curvaceous figure (molded in clinging satin), and once again in romantic fervor. For her first musical (title song by Jerome Kern), a third pose was included, showing the actress in midstep. It was a deception, actually, since Harlow was so inept at singing and dancing that doubles were used. The pastel drawing relied in part on Coles Phillips' "fade-away" technique by using the background color as a design device.

Anna Karenina
MGM, 1935

The legendary Greta Garbo is illustrated here by Ted Ireland (better known as "Vincentini"), a specialist in glamour star portraits. Garbo is shown in three poses for her title role as the wife of a Russian aristocrat in the black-and-white screen version of the Leo Tolstoy novel. A bluish-green background that becomes part of the portrait itself is rarely seen, as blue is considered unflattering for skin tones.

A Night at the Opera
MGM, 1935

Albert Hirschfeld's glorious caricature of the zany Marx Brothers (Groucho, Chico, and Harpo) for their first film without brother Zeppo is simply vibrant. While the piece is dominated by the three stars, the artist's striking use of color and innovative design leaves little doubt that the show is a comedy with music.

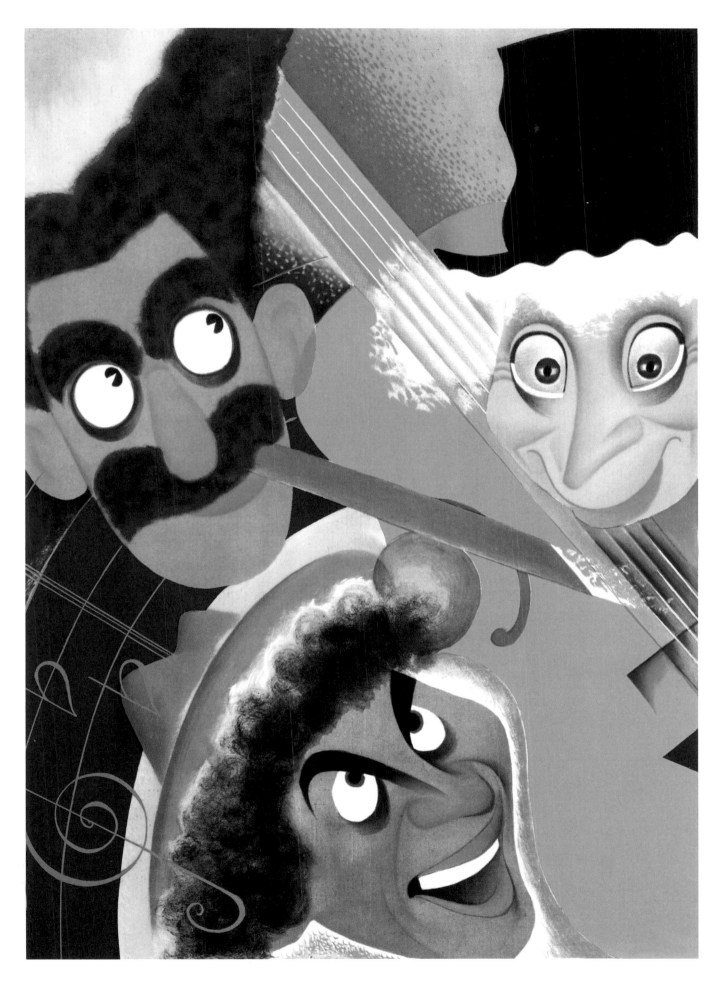

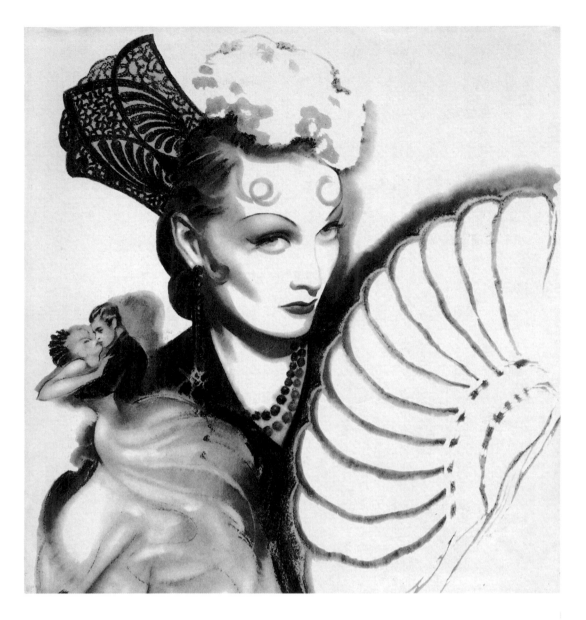

The Devil Is a Woman
Paramount, 1935

European-born artist Hans Flato was brought to Paramount in the early 1930s to capture *femme fatale* Marlene Dietrich's lusty allure for the studio's promotion of her film *Blonde Venus* (1932). His visual presentation of the actress, believed to be the studio's answer to MGM's Garbo, won him work on additional Dietrich assignments. *The Devil Is a Woman* was forever Dietrich's favorite film, not because of her performance but "because I was most beautiful in it."

I Dream Too Much
RKO, 1935

The success achieved in films during the early 1930s at MGM and Columbia by Broadway and Metropolitan Opera star soprano Grace Moore prompted RKO to bring another celebrated Met vet to Hollywood. For the screen debut of French-born Lily Pons, the coloratura was given Henry Fonda as her leading man and a quartet of songs by Jerome Kern and Dorothy Fields. The diminutive Pons also received the glamour treatment, highlighted by this flattering portrait in fiery colors by an uncredited studio artist under the guidance of art director David L. Strumf.

Broadway Melody of 1936
MGM, 1935

Star identity may have been lacking in this piece of artwork (the film boasted such headliners as Eleanor Powell, Jack Benny, and Robert Taylor), but there is no mistaking the lively tone of this musical extravaganza from the colorful, action-packed watercolor supervised by art director Hal Burrows. The black-and-white film was the second in the series of four popular *Broadway Melody* movies.

Magnificent Obsession
Universal, 1935

While other studios experimented with graphics, aiming their appeal to exhibitors and ticket-buyers through newer, more "modern" techniques and layouts, Universal maintained its successful yet rather subdued approach. Here, for the screen version of Lloyd C. Douglas' best-selling contemporary novel, the studio provided a monochromatic period treatment. Artist Hy Rubin created the central "peephole" design with its delicate hatching. The ornamental filigree was probably the work of another artist, supervised by art director Karoly Grosz.

Mutiny on the Bounty
MGM, 1935

Blazing colors of the tropics illuminate this pastel rendering for the filmed adaptation of the Nordhoff-Hall story of adventure on the high seas. Shown, sans watery backgrounds or lush island settings, are three of the movie's pivotal characters: the tyrannical Captain Bligh (Charles Laughton, ominously shadowed in blue); the gallant Fletcher Christian (Clark Gable); and Movita, as the native girl.

Follow the Fleet

RKO, 1936

There is no mistaking the theme of this Fred Astaire and Ginger Rogers film musical. In their fifth pairing, the greatest of all screen dance teams literally soars across the page with a burst of explosive seafaring energy, as if to conquer space and all else with their magical talents. The unsigned watercolor rendering is the work of artist Widhoff.

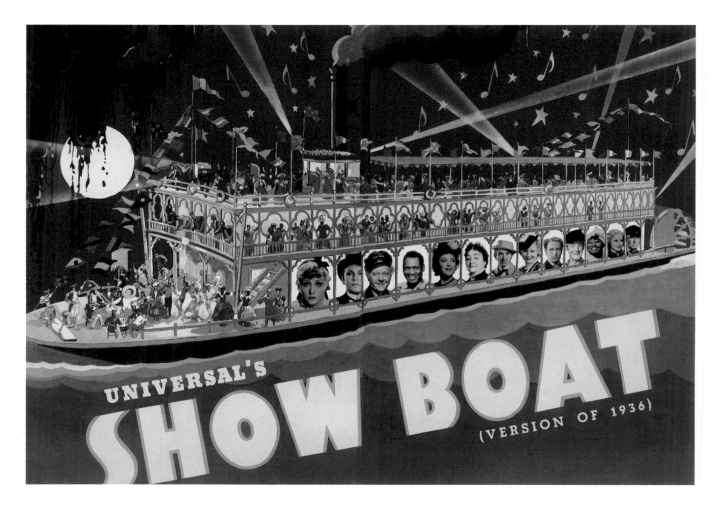

Show Boat
Universal, 1936

For the second filming of Edna Ferber's novel, based on the Oscar Hammerstein II/Jerome Kern adaptation of the 1927 Broadway musical, the studio loaded the decks with stars. By the mid-1930s, however, the show itself, with its score of hit songs, had become such a major attraction that no mention of the all-star cast was necessary. Seemingly more important was the disclaimer "Version of 1936," so that it would not be confused with the primitive early talkie released in 1929. The poster-like ad, originally printed as a double-page spread, bursts with excitement and song, leaving no doubt that it was one of the biggest films of the year.

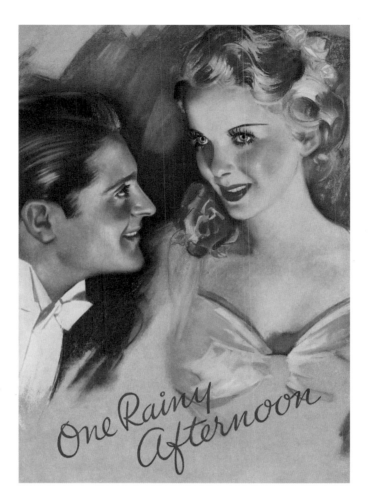

One Rainy Afternoon
United Artists, 1936

Francis Lederer and 18-year-old Ida Lupino are caught in a lush
pastel rendering by an uncredited studio artist, whose style is typical
of illustrations for romantic fiction in magazines of the day. The art
leans heavily on the attraction between the two central characters,
suggesting a certain innocence in this fast-paced, light comedy.
While sitting in a darkened movie theater, an impetuous young
man, presumably under the spell of the film, kisses the young girl
sitting next to him. Ad line: "A kiss in the dark brings to light the
merriest love story of the year."

After the Thin Man
MGM, 1936

America's favorite fun-loving detectives, Nick and Nora Charles (along with their dog, Asta), received the glamour treatment from Ted Ireland for the second in the highly popular Thin Man series. The unflappable "perfect couple" was played by William Powell and Myrna Loy.

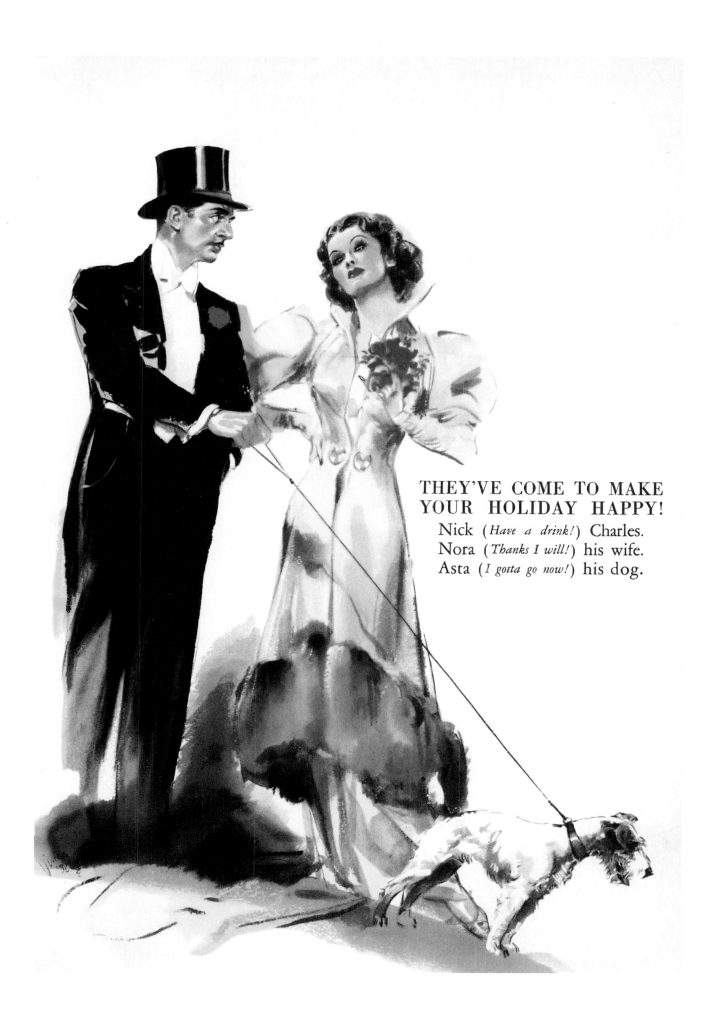

THEY'VE COME TO MAKE YOUR HOLIDAY HAPPY!

Nick (*Have a drink!*) Charles.
Nora (*Thanks I will!*) his wife.
Asta (*I gotta go now!*) his dog.

Under Two Flags
Twentieth Century-Fox, 1936

Taking his cue from the torrid colors of a desert inferno, the setting for this
epic film about a French Foreign Legionnaire and his camp follower girlfriend,
an uncredited studio artist relied heavily on scorching reds and yellows to por-
tray the film's four stars—Ronald Colman, Claudette Colbert, Rosalind Rus-
sell (above), and Victor McLaglen—in full-page promotional portraits. Each
rendering incorporates suggestions of scenes from the black-and-white film,
with its cast of more than 10,000 extras, highlighted in complementary colors.

VICTOR McLAGLEN

("The Informer"—NOW
"Under Two Flags")

Violent, ruthless commandant
of the Foreign Legion . . .
toughened by ceaseless battle
and scorching sun to every
peril . . . except the inviting
eyes of an alluring girl!

Libeled Lady
MGM, 1936

For one of its top releases of the year, the studio used a modified bull's-eye, centered with glamorous star portraits by "Vincentini" (Ted Ireland). The outer band, containing the movie's title and surnames of the four leads—Harlow, Powell, Loy, and Tracy—was printed in a non-reflective silver ink. The film was later remade as the 1953 musical *Easy to Love,* starring Esther Williams, Van Johnson, Tony Martin, and, in her first film, Carroll Baker.

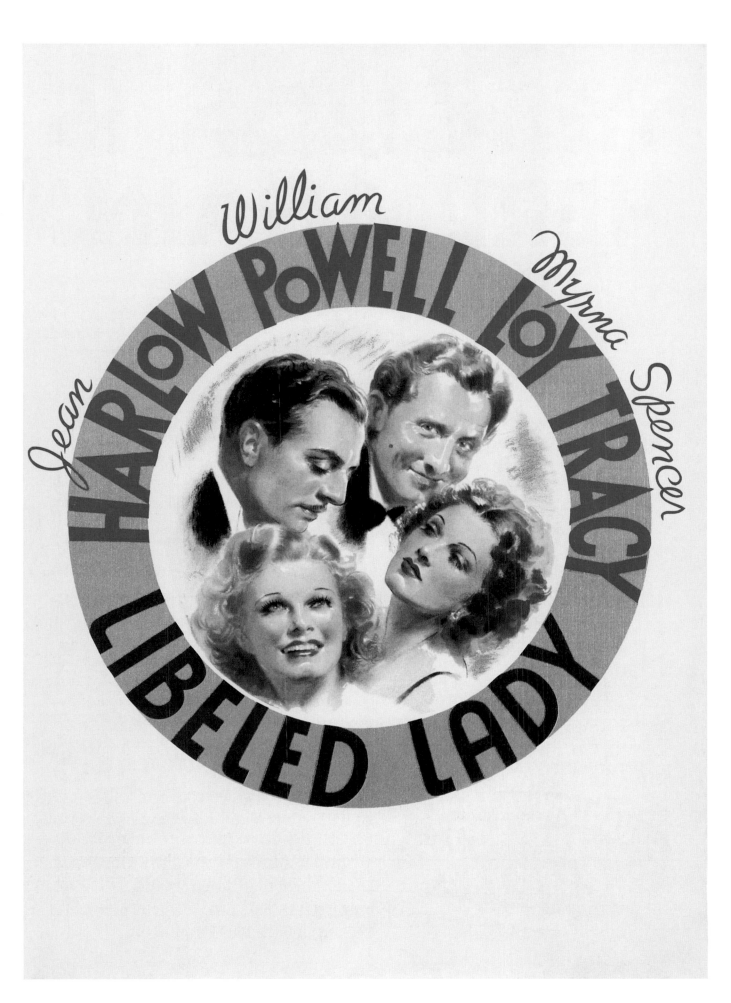

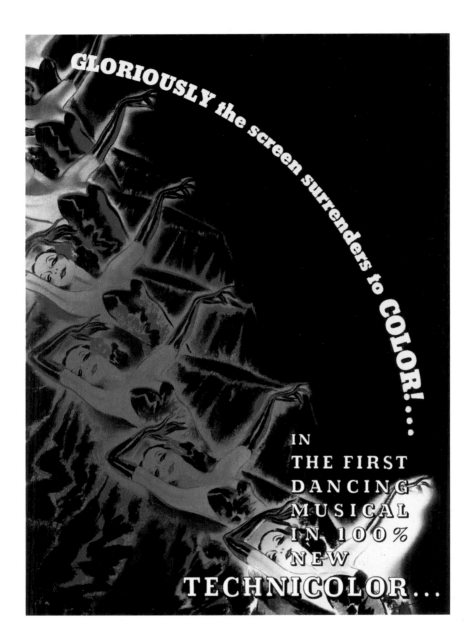

The Dancing Pirate
Pioneer/RKO Radio, 1936

Pioneer Pictures released only two films: the first full-length motion picture in the new full-color Technicolor process (*Becky Sharp,* 1935), and this first feature-length full-color musical. (The new Technicolor process had been used by Disney for animated cartoons since 1932, and in live action shorts and sequences for feature films since 1934.) For its landmark musical production, with songs by Richard Rodgers and Lorenz Hart, Pioneer created a dramatic campaign that featured dancing girls and sizzling colors against a field of black. The emphasis was on color! color! color!

Dimples
Twentieth Century-Fox, 1936

Beginning in 1934, Alberto Vargas worked briefly for several studios before moving to *Esquire* magazine and fame as creator of "The Varga Girl" (he dropped the "s" at *Esquire,* thinking it sounded better). At Twentieth Century-Fox, Vargas produced pastel portraits of all the studio's stars, including this colorful pose of spunky Shirley Temple, which was used as part of the exhibitor promotion for her role as a New York Bowery child. To this day a Vargas oil portrait of Temple hangs in the Shirley Temple Room of the studio commissary.

Camille
MGM, 1936

The Ted Ireland technique was once again called upon as the studio planned its exhibitor promotion for the fourth filmed version of Dumas' great romantic tragedy, this time starring the magnetic Greta Garbo in the title role and Robert Taylor as her lover, Armand. The intense magenta background, with splashes of orange and red, evokes emotions of fiery passion.

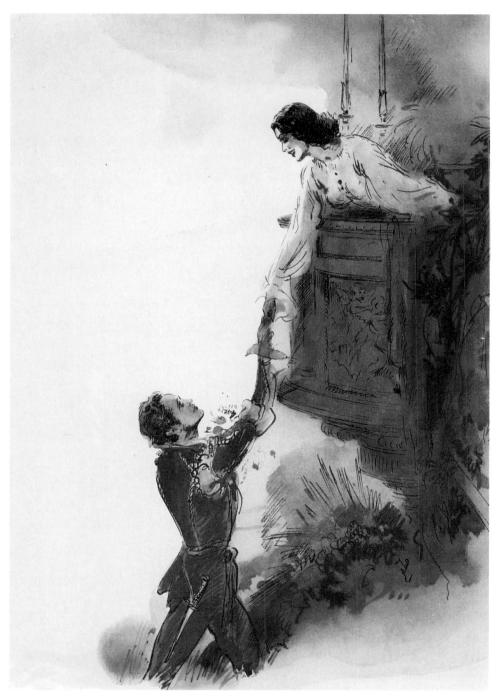

Romeo and Juliet
MGM, 1936

Ted Ireland (a.k.a. "Vincentini"), MGM's romance specialist, produced this elegant two-color pen-and-ink drawing of the balcony scene from the Shakespeare tragedy. Showcased are the classic ill-fated lovers, portrayed in the film by Leslie Howard and Norma Shearer.

Love on the Run
MGM, 1936

This highly contemporary caricature by Abe Birnbaum was first commissioned in 1933 for the Joan Crawford–Clark Gable film *Dancing Lady,* but was considered too extreme at the time. The art was put on hold for three years, then used for another pairing of the stars. This unusual double portrait drew attention to the stars while overlooking the plotless storyline.

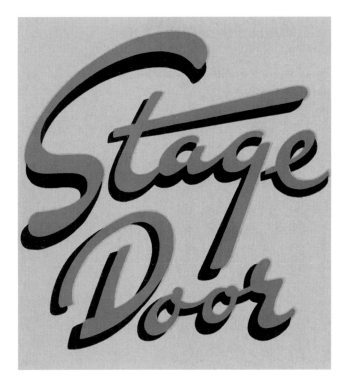

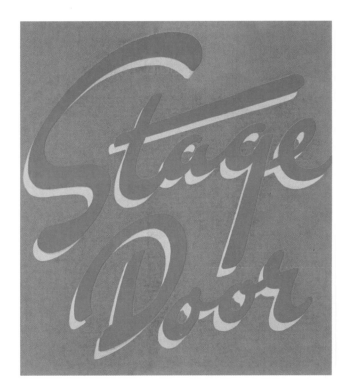

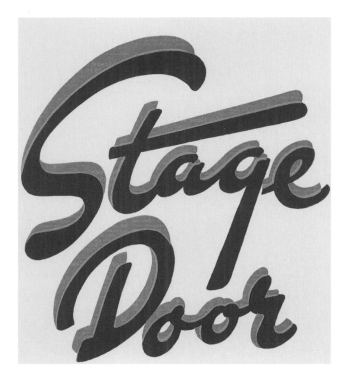

Stage Door

RKO, 1937

To promote the filmed adaptation of the George S. Kaufman–Edna Ferber Broadway hit, the studio created a series of striking graphics that used only the film's title. The large, bold script took full advantage of the space, and with each appearance in print was seen in different color combinations. Here are four from this unusual series: orange script with black shadowing against silver; emerald green script with pale green shadowing against gold; blue script with gold shadowing against white; and bright yellow script with silver shadowing against a rich blue background.

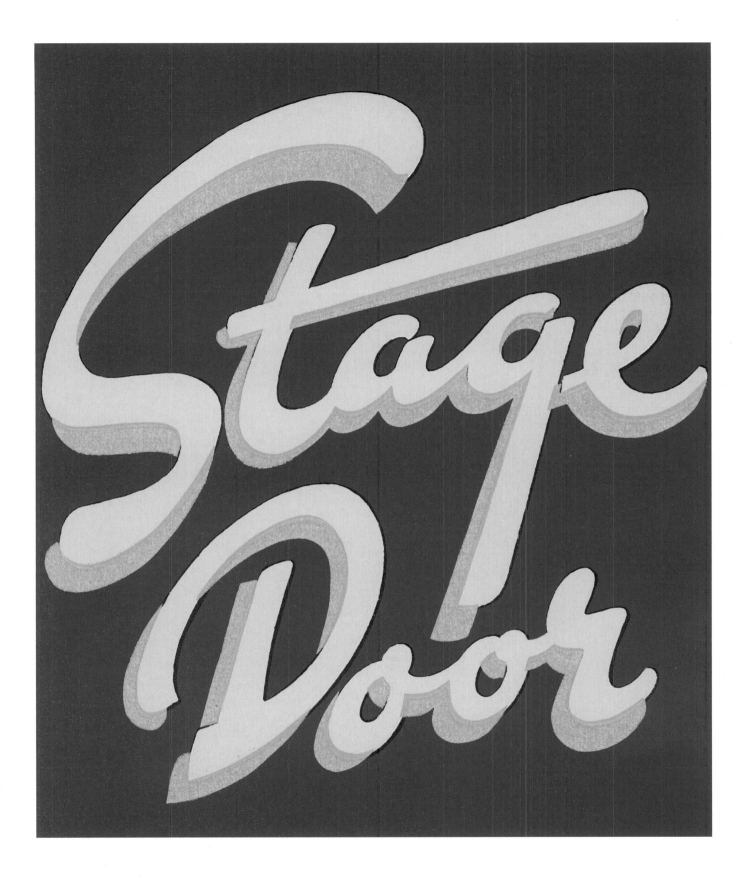

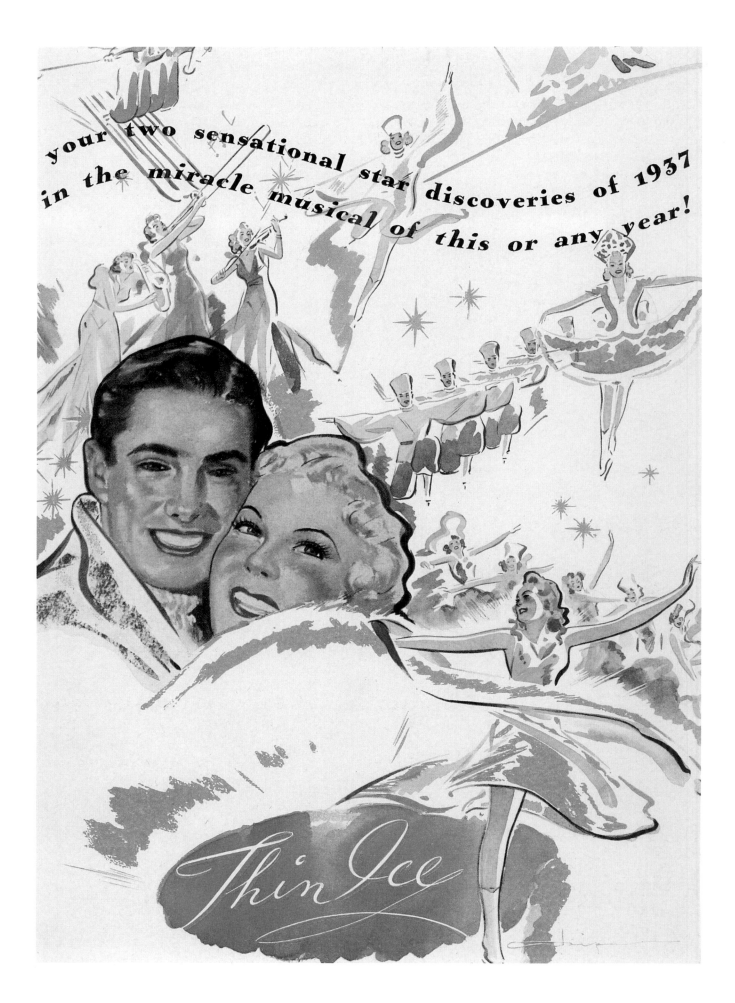

Thin Ice
Twentieth Century-Fox, 1937

The studio paired its hottest young stars—handsome, dark-haired Tyrone Power and blond, blue-eyed, three-time Olympic ice skating champion, Sonia Henie—and put them in a winter wonderland for its story about a visiting prince who falls in love with a skating instructor. This lively watercolor by Isep, one of the studio's staff illustrators, sings with pastel colors set on a field of snow white. Silver ink, in snowflakes and brushstrokes, provides icy accents.

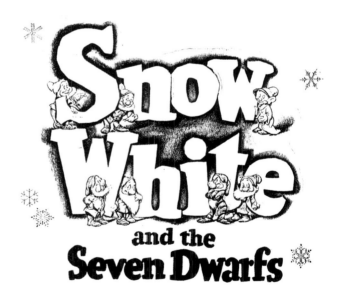

Snow White and the Seven Dwarfs
Disney, 1937

Swedish illustrator/animator Gustaf Tenggren created this graphic for Disney's first full-length animated feature. The dwarfs are shown peeking playfully around the Snow White portion of the logo. The black-and-white art for the full-color film was topped by the headline: "It took 1,000 artists three years to make it!"

Vogues of 1938
Wanger/United Artists, 1937

For "the screen's first fun and romantic fashion comedy in Technicolor," watercolorist Ronald McLeod, working with art director Herbert Jaedicker, created a joyous montage filled with elegance, style, and song. Prominently displayed in full figure are stars Warner Baxter and Joan Bennett (in the role turned down by Carole Lombard, who was at first fearful of appearing in Technicolor), along with portraits of supporting cast members Mischa Auer, Helen Vinson, and Alan Mowbray.

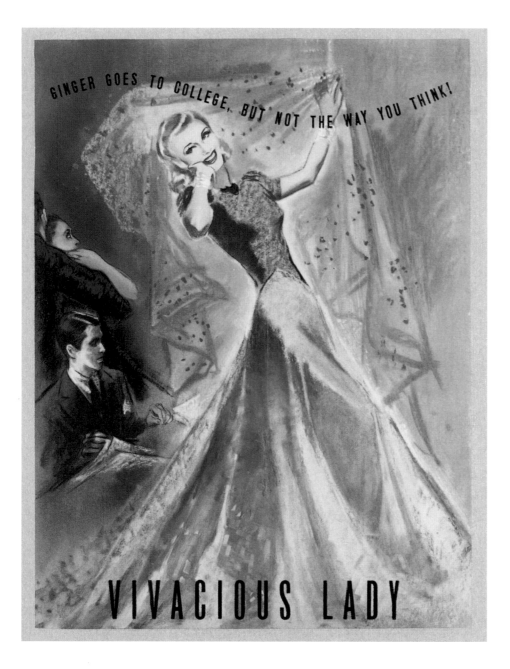

GINGER GOES TO COLLEGE, BUT NOT THE WAY YOU THINK!

VIVACIOUS LADY

Vivacious Lady
RKO, 1938

Although Ginger Rogers was as skilled at drama and comedy as she was as the dancing partner of Fred Astaire, the public longed to see her on a dance floor. So it was only natural for illustrator William Rose to set Ginger in motion for her role as a night club singer in this warm-hearted slapstick comedy. Rogers, whose star was already sky-high, received the full-color treatment while James Stewart, with his great stardom still ahead, is pictured in monochromatic tones. Surrounding the poster-like art is a band of metallic silver.

Her Jungle Love
Paramount, 1938

Moviegoers first caught a glimpse of Dorothy Lamour in a sarong in *Jungle Princess,* a black-and-white film released in 1936. It was so profitable that within two years Lamour, her sarong, and her earlier co-star, Ray Milland, were back on the screen, this time with a bigger budget and the tropical trappings lushly photographed in full color. ("The first jungle picture in Technicolor," cried the ads in multi-hued letters.) An uncredited artist captured one of the film's quiet moments—a rare respite between an earthquake and a volcanic eruption—to show the two stars and Gaga, the pet chimpanzee, in a romanticized setting.

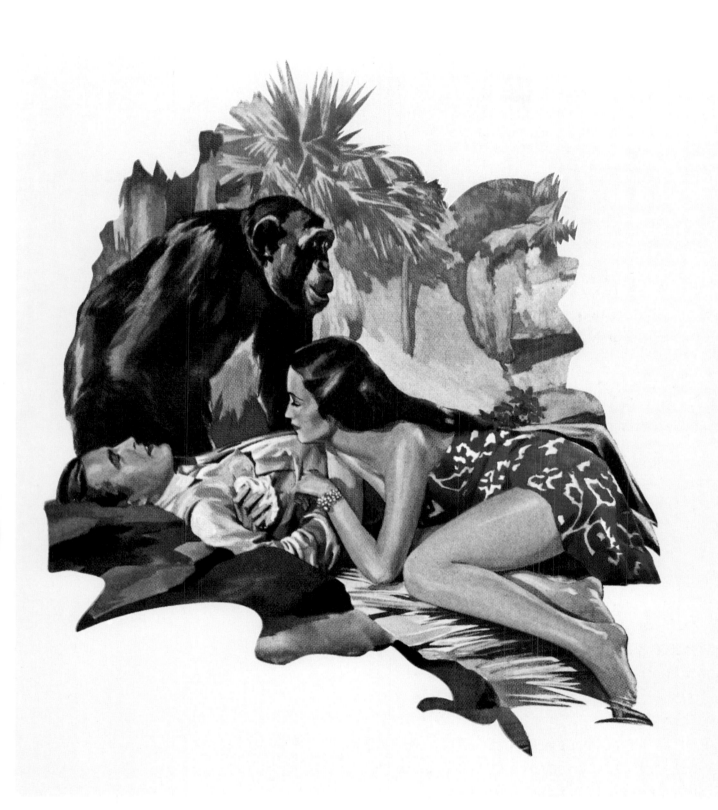

GARY COOPER in *The Adventures of* MARCO POLO

The Adventures of Marco Polo
Goldwyn/United Artists, 1938

Strong, silent Gary Cooper is shown in full figure against an elaborate panoramic backdrop of Far Eastern scenes and characters by artist Robert C. Lee, guided by art director Herbert Jaedicker. There is no mistaking the film's Oriental theme here, or the ambitiousness of the production. The full-color treatment added an extra ingredient that the film itself lacked.

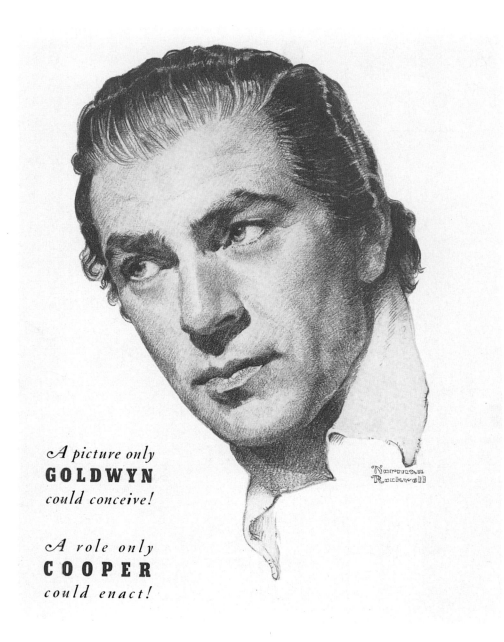

A picture only
GOLDWYN
could conceive!

A role only
COOPER
could enact!

The Adventures of Marco Polo
Goldwyn/United Artists, 1938

In a departure from the film's billboard-style concept art, a sketch by Norman Rockwell showcases the singular star power of actor Gary Cooper as the title character, reproduced full-page in sepia as part of the exhibitor promotion. Rockwell frequently sketched portraits of cast members for movies, but he did them from photographs after filming was completed.

Punch!

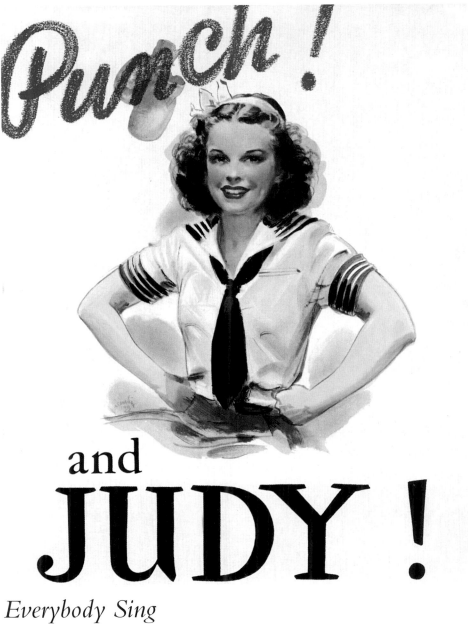

and JUDY !

Everybody Sing
MGM, 1938

Teenager Judy Garland was still a year away from stardom when she appeared in this family musical comedy with Allan Jones and Fanny Brice. The studio thought so highly of her it showed her exclusively in a two-page trade promotion for the film. Ted Ireland's wholesome rendering of a young, smiling Garland dominated one page, set between the words "Punch! . . . and Judy!" The other page told briefly of her discovery by the studio only months earlier, and of her quick rise to fame.

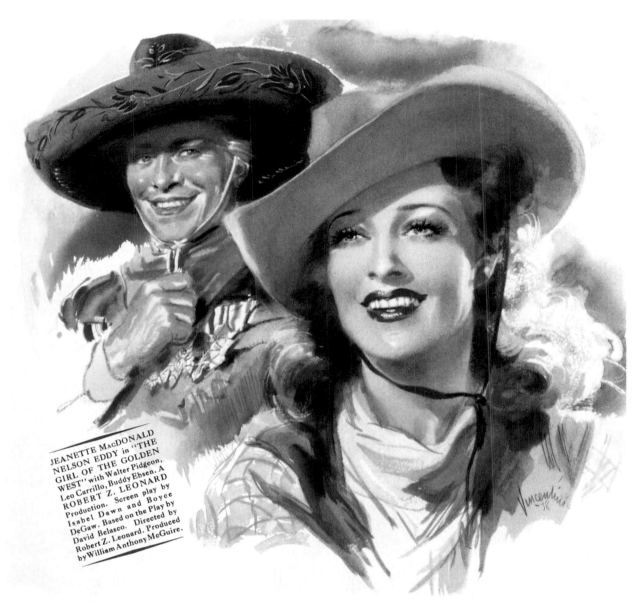

JEANETTE MacDONALD NELSON EDDY in "THE GIRL OF THE GOLDEN WEST" with Walter Pidgeon, Leo Carrillo, Buddy Ebsen. A ROBERT Z. LEONARD Production. Screen play by Isabel Dawn and Boyce DeGaw. Based on the Play by David Belasco. Directed by Robert Z. Leonard. Produced by William Anthony McGuire.

The Girl of the Golden West
MGM, 1938

MGM's annual go at light opera, starring the phenomenally successful singing team of Jeanette MacDonald and Nelson Eddy, received the lushly romantic Ted Ireland treatment in full color. According to art director Hal Burrows, the two stars, dressed in period costume, were the only visual elements needed to attract attention. No attempt was made to visualize the film's other key ingredients: new songs by the renowned Sigmund Romberg and Gus Kahn, a lively mariachi sequence, and glorious outdoor cinematography shot in sepiatone.

Carefree
RKO, 1938

What more need be said—or shown—about a Fred Astaire/Ginger Rogers film, with songs by Irving Berlin, than to simply list the key elements? Nothing, really. This all-type graphic, heavily sprinkled with silver stars for a festive dash, was designed by an uncredited studio artist, with art direction by David L. Strumf.

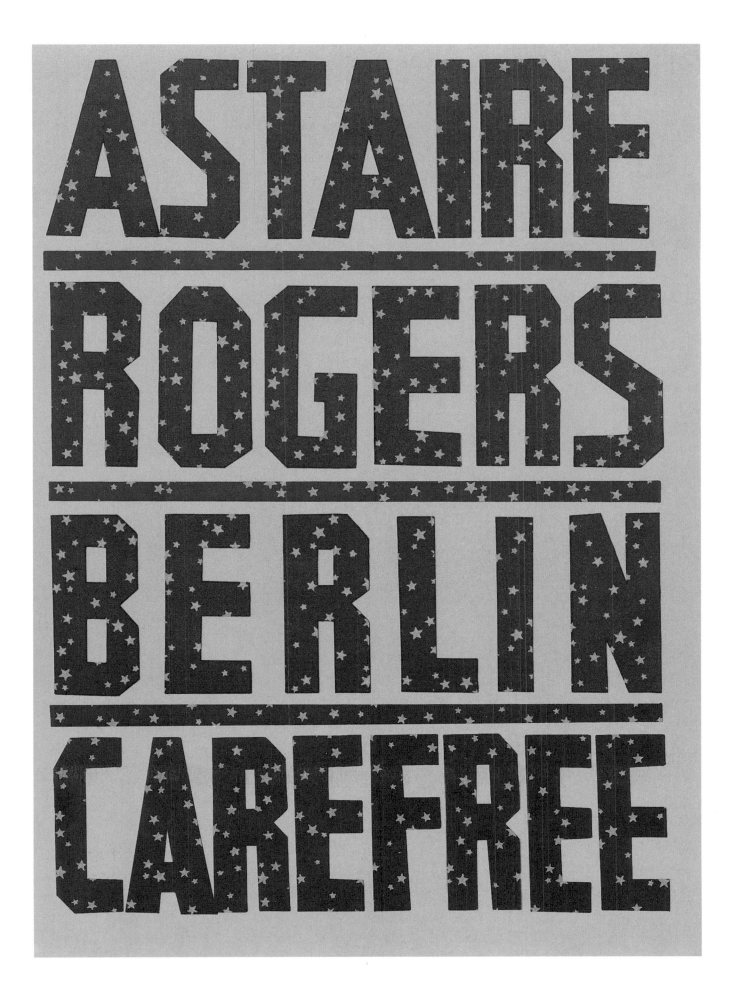

ASTAIRE
ROGERS
BERLIN
CAREFREE

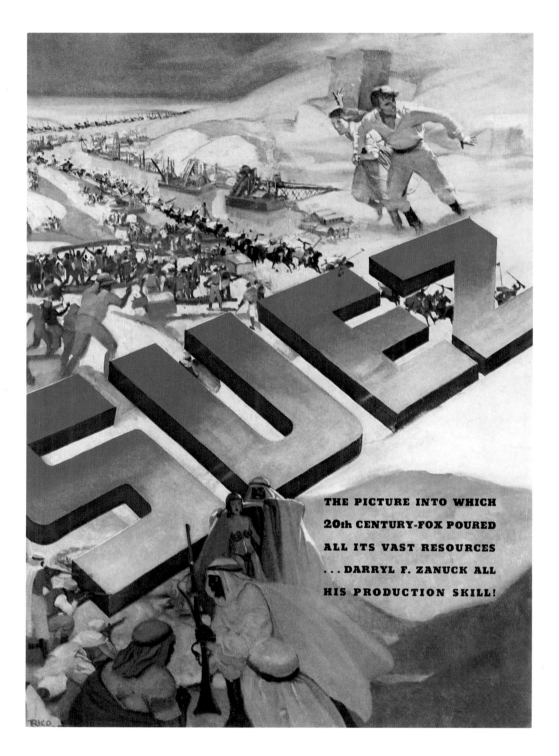

THE PICTURE INTO WHICH
20th CENTURY-FOX POURED
ALL ITS VAST RESOURCES
...DARRYL F. ZANUCK ALL
HIS PRODUCTION SKILL!

Suez
Twentieth Century-Fox, 1938

An action-packed panorama by Rico Tomaso sets the tone for this
sprawling saga about the man who built the Suez canal. The artist,
under the direction of Louis Shanfield and Theodore Jaedicker, chose
to illustrate the film's adventurous quality rather than rely on the star
magnetism of Tyrone Power, Loretta Young, and Annabella.

Hollywood Cavalcade
Twentieth Century-Fox, 1939

This story of Hollywood in the days of silent films (supposedly based on the lives of Mack Sennett and Mabel Normand) is part melodrama, part slapstick comedy, with performances by such early stars as the original Keystone Kops and Buster Keaton. Although the film was shot in Technicolor, the primary (uncredited) promotional art was in black and white. Thematic elements within the story can be seen in both the photo montage, featuring top-billed Alice Faye and Don Ameche, and illustration that casts a spotlight on the title lettering.

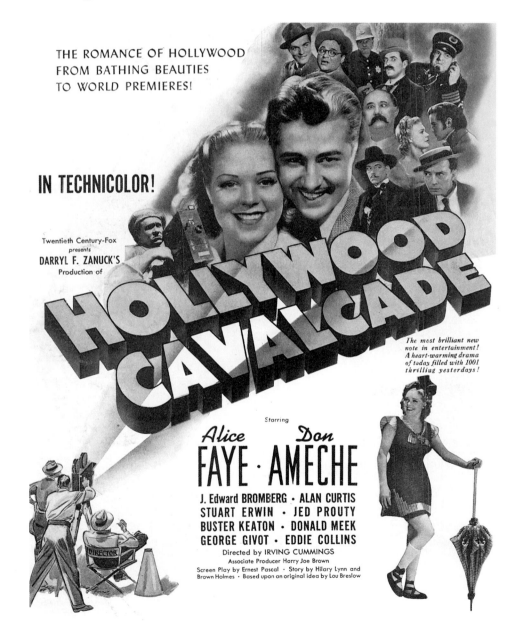

Juarez
Warner Bros., 1939

The subdued profiles of Bette Davis, as Empress Carlotta, and Paul Muni, as Mexican President Benito Juarez, represent opposing forces smoldering beneath the surface in this graphic for Warner's grand historical drama. The strong black–and–white art, a combination of photography and airbrush, was typical of the studio's visual flair for the dramatic, which was dominated for a time by the use of photographic images.

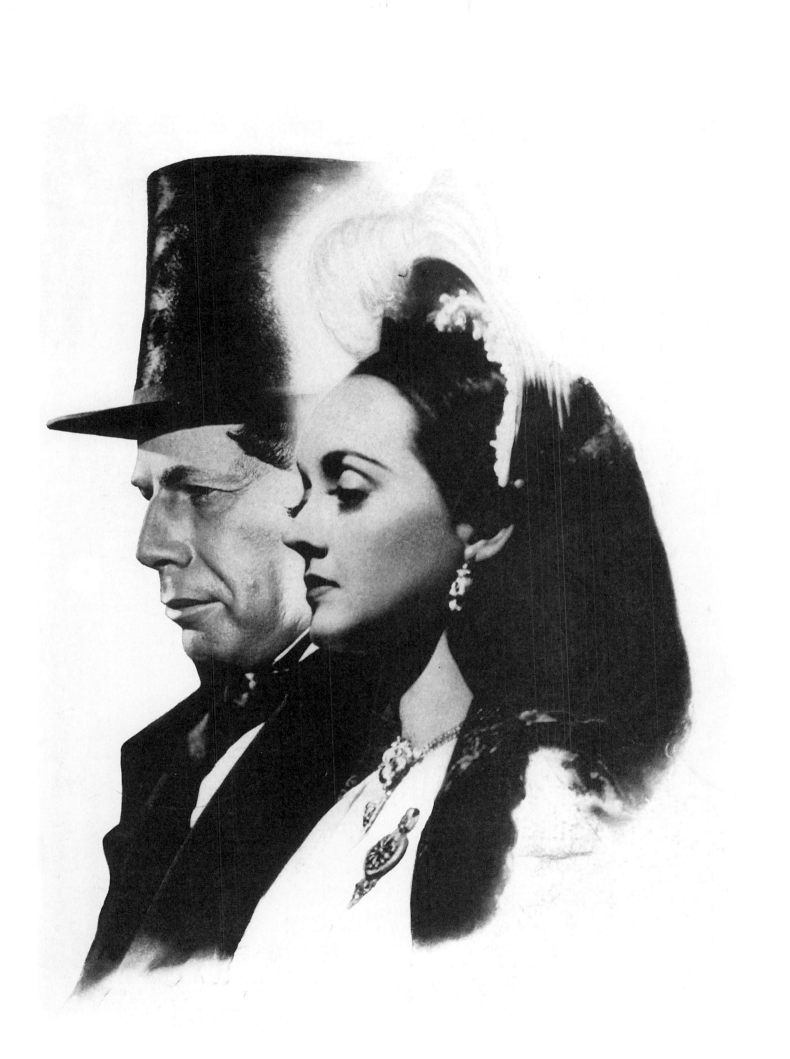

Part Three

The Forties

At the start of the new decade, America had yet to be drawn into the war that raged in Europe. Headlines and news reports detailed the horrors from the fiery battlefields. The American public joined in wanting a victory for its allies, yet prayed that the United States would not become involved.

Though only an observer, Hollywood was nearly paralyzed for a time by the war overseas. Movies dealing with espionage, refugees, and the struggle between other countries would bring these sensitive subjects closer to home than they really were, and the public was uneasy enough as it was. Studios either stopped production on these films, postponed, or cancelled them.

The bombing of Pearl Harbor on December 7, 1941, and America's entry into World War II changed all that. Now Hollywood not only went to war, but threw itself enthusiastically into a patriotic attempt at bolstering the morale of the country. Virtually every type of subject matter was readied for the cameras, from musicals, comedies, and Westerns to crime and combat. The public yearned for escapist fare and romance, especially if it smacked of sentimentality and bravery. A story that told of a family's stalwart struggle or a young couple's parting or reuniting had enormous appeal.

As Hollywood took to uniforms—and many of the top male stars did join the service—the glamour and elegance of the thirties began to fade. In their place came a wholesome sexiness and stardom to a new crop of female stars. Betty Grable, Rita Hayworth, Lana Turner, Ann Sheridan, Jane Russell, Esther Williams, and Veronica Lake became the G.I.'s favorite pin-ups; June Allyson, Judy Garland, Joan Leslie, Jennifer Jones, Gail Russell, and Joyce Reynolds became "the girls next door," the sweethearts they left behind.

The public's hunger for escapism made the movies the big entertainment of the times, even well into the postwar period of the late forties. Fan magazines also zoomed in popularity and power thanks to behind-the-scenes stories on stars and a growing number of star portraits in full color. By this time the camera had taken over, but many of the most memorable illustrations were by recognized artists like James Montgomery Flagg, who had traveled from the excitement of New York's legitimate theater to Hollywood's movie industry to supply charcoal portraits of stars for each issue of *Photoplay*. (Flagg, who never claimed to be a fine artist, once said, "The only difference between a fine artist and an illustrator is that the latter can draw, eats three square meals a day, and can afford to pay for them.") The outspoken and often blunt Flagg had earlier visited the film capital to sketch John Barrymore, Jean Harlow, and William Powell, and he had his favorite subjects among the Hollywood crowd. Of Hedy Lamarr he commented, "It would only be a blind and deaf man who wouldn't fall in love with her. She would be the only living woman I would forgive for not having breasts." Of Greta Garbo: "I can think of no woman I would prefer to draw and paint." On women in general: "Physical beauty is not enough. To be really beautiful a woman must have certain fundamental qualities of spirit—serenity, kindness, courage, humor, and passion."

While Flagg contributed little to the promotional art of the period, there certainly was no shortage of established illustrators working in and with the film industry. Norman Rockwell, Alberto Vargas, Cecil Beall, Albert Hirschfeld, Mario Cooper, Armando Seguso, Ted Ireland, and others created visuals for numerous plum projects aimed at the general public (fan magazines were the big market), as well as

"insiders only" trade publications. Much of their work, particularly the poster art, is today highly sought after by collectors.

During the war years (1941-1945), shortages of quality paper stock and art materials mandated a greater simplicity of design. It was to the illustrator's advantage to use areas of clean, flat color rather than clutter or stark, high contrasts, which tended to show through on the reverse side of the page. Escapist subject matter was at its height, along with the competition between studios. It had always been keen, but now, with filmgoers flooding the movie houses, the fight for the entertainment dollar grew even stronger.

Corporate identity was more important than ever. Each of the studios strove for its own distinctive "look" in advertising, hoping to attract audiences to a specific stable of stars, stories, and style of filmmaking. MGM, for instance, was known for its clean, classy, and elegant look. Twentieth Century-Fox opted for fun and splash. No look was more unmistakable, however, than that of Warner Bros., whose ads contained few illustrations. Instead, they were dominated by big and bold handlettered brushstrokes. It worked for the majority of their films, which were dark, moody dramas, as well as for lighter fare.

The boom period that had marked most of the forties would soon come to a close. Ahead, there were problems for the movie industry, and while it was not yet time to panic, disturbing clouds lingered on the horizon. The era of what would one day be affectionately known as Hollywood's "Golden Age" was coming to an end.

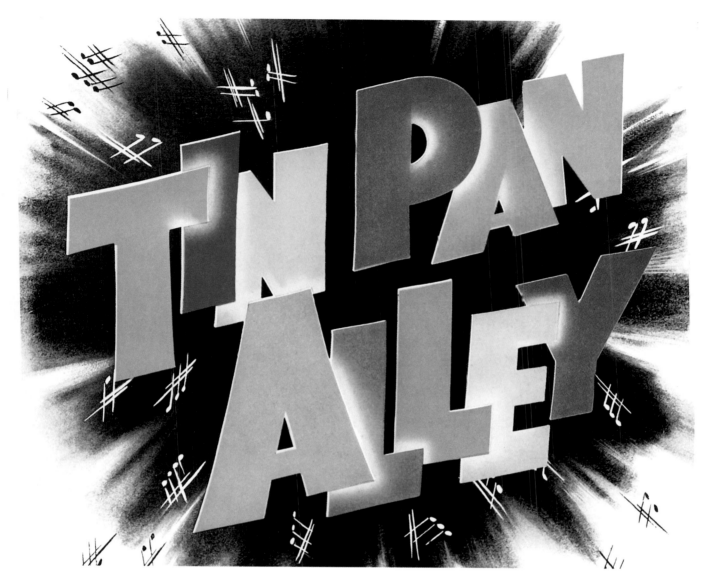

Tin Pan Alley
Twentieth Century-Fox, 1940

Following Betty Grable's star-making success in her picture-postcard Technicolor debut for Twentieth Century-Fox (*Down Argentine Way,* 1940), she was paired with Alice Faye in a black-and-white musical. The dazzling logo, while implying that the film was in color, left little doubt that it represented another tuneful romp for it stars. It was created by Fox's art department under the guidance of Charles Schlaifer, director of advertising and publicity, and Jerome Novak, art director.

Ziegfeld Girl
MGM, 1941

Florenz Ziegfeld was one of the greatest names in show business. His "Ziegfeld Follies" were a staple on Broadway for decades, always star-studded, super-colossal entertainments decorated with spectacularly gowned showgirls. Following MGM's success with *The Great Ziegfeld* in 1936 (the grand-scale biographical picture won two Academy Awards: Best Picture, and Best Actress for Louise Rainer), the studio mounted a production that was nearly as opulent. *Ziegfeld Girl* told the story of three young women who come to New York with the hopes of stardom in the "Follies." With its all-star cast, headed by Judy Garland, Lana Turner, Hedy Lamarr, and James Stewart, plus ultra-lavish sets, gorgeous gowns, songs, Busby Berkeley production numbers, and plenty of drama, it had something for everyone. How best to visualize it all in a single graphic? The art department opted for simplicity and symbolism by showing Ziegfeld's most famous trademark. Here she is, dramatically posed and sprinkled with stars. You can almost hear the orchestra playing!

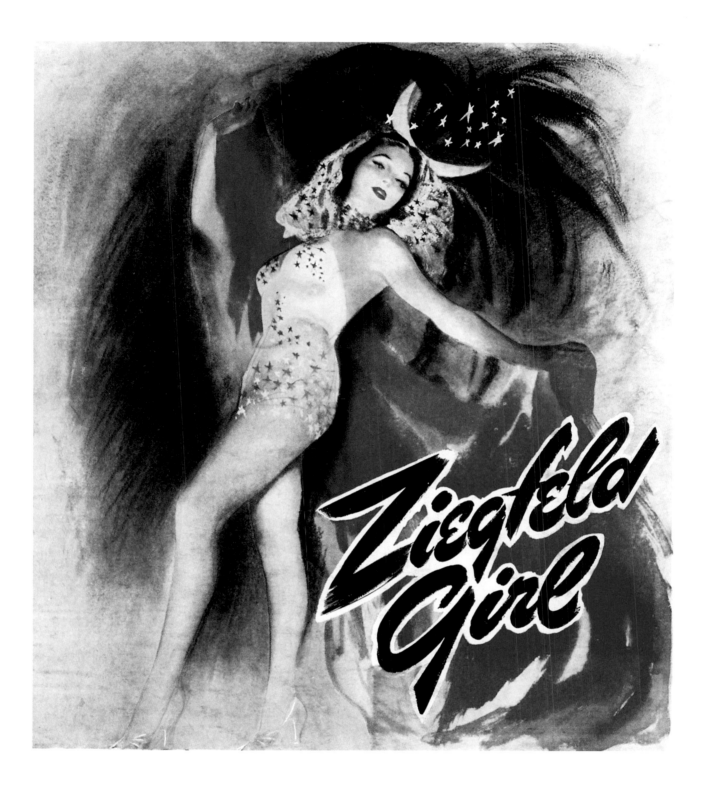

Moon Over Miami
Twentieth Century-Fox, 1941

Alberto Vargas, whose sexy calendar girls for *Esquire* magazine were creating a sensation, returned to Fox in 1941 at the request of advertising and publicity director Charles Schlaifer. (Vargas, who signed his art "Varga," had dropped the "s" in his name when contracted by *Esquire* the previous year, believing the modified spelling sounded more pleasing. He had been hired to replace the magazine's resident girlie artist, George Petty, whose stylish watercolor and airbrush technique helped pull the publication through the Great Depression.) At Fox, Schlaifer felt a need for very distinctive art to "sell" an upcoming Technicolor musical and its new star and rising pin-up girl, Betty Grable. The result was a dreamily posed Grable in a bright red bathing suit, as seen from a bird's-eye view.

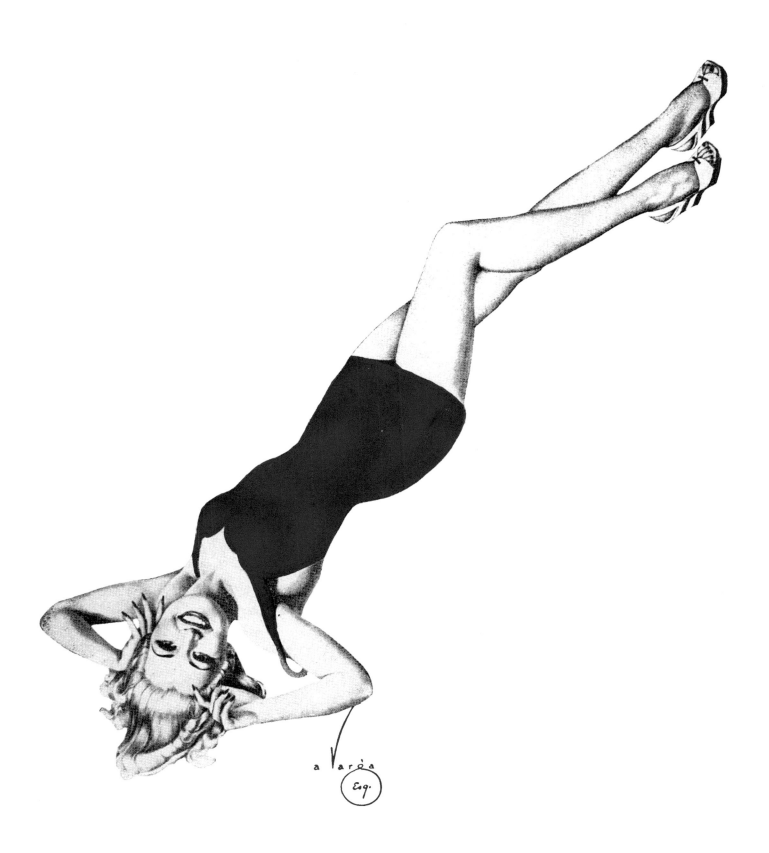

Each of the following eight Jacques Kapralik collages from 1941-1942 incorporates for the first time his trademark signature, an encircled "K." Although all of these movies were filmed in black and white, Kapralik dazzled the senses with his brilliant and creative use of color.

Honky Tonk
MGM, 1941

Two of the studio's biggest stars, Clark Gable and Lana Turner, receive the Kapralik treatment for this romantic Western about a gold rush gambler and his goodtime gal. For added interest, the artist embossed the jewelry worn by the two leads with raised ink, Gable's in gold, and Turner's in silver.

Babes on Broadway
MGM, 1941

Yarn, fabric, and paper against a painted backdrop of a stage door were the materials used to caricature Judy Garland and Mickey Rooney for this story of talented teenagers who sing and dance their way to Broadway.

Johnny Eager
MGM, 1942

Glamour girl Lana Turner's pairing with Clark Gable in *Honky Tonk* was such a hit at the box office that the studio soon teamed her with its other resident hunk, Robert Taylor. The result was the "Tn'T" (Taylor n' Turner) national advertising campaign. While Kapralik's approach was not nearly as explosive, it did suggest the smoldering possibilities by showing the dynamite pair being held at bay by a boudoir window.

Rio Rita
MGM, 1942

Bud Abbott and Lou Costello were the hottest comedy team of the 1940s, making every list of top ten box office attractions. They were such money-makers that MGM, despite its already vast roster of stars, *had* to have them for its remake of the lavish 1926 Broadway musical-Western and highly successful early filmed talkie version (1929). On loan from their home studio, Universal, Abbott and Costello dominated the film to such an extent that co-stars Kathryn Grayson and John Carroll all but disappeared in the hi-jinks. Taking his cue from art director Hal Burrows, Jacques Kapralik constructed one of his most elaborate and colorful collages exclusively around the profiled likenesses of the two comedians. As always, the artist's eye for atmospheric detail is evident.

Random Harvest
MGM, 1942

The story of an amnesia victim (Ronald Colman) and his stalwart wife (Greer Garson), a former music hall singer whom he no longer remembers, is given a strangely elegant treatment by Kapralik. The collage, conveying the subject's sense of detachment, makes us wonder whether the object in Colman's hand is the key to his memory. The decorative filigree surrounding the theater box in which the two stars are seated is embossed with gold ink.

I Married an Angel
MGM, 1942

It took nine years to get Jeanette MacDonald into this musical fantasy about a playboy who dreams he marries a virginal angel. The saga started in 1933 when MGM bought the rights to lure the singing star into signing a longterm contract. She signed, and the studio promptly hired Richard Rodgers and Lorenz Hart to write the score. Before the first roll of the cameras, however, the somewhat risqué storyline ran into censorship problems, forcing the studio to shelve the project. In 1938, the Rodgers and Hart musical opened on Broadway starring Vera Zorina and Dennis King. With renewed interest, the original storyline was toned down for the movies and rewritten as a vehicle for Jeanette and Nelson Eddy—"America's Sweethearts"—the most successful singing duo in screen history. For their ninth and final film together, Kapralik created a heavenly collage of the newlyweds soaring on a cloud-like chariot to the stars.

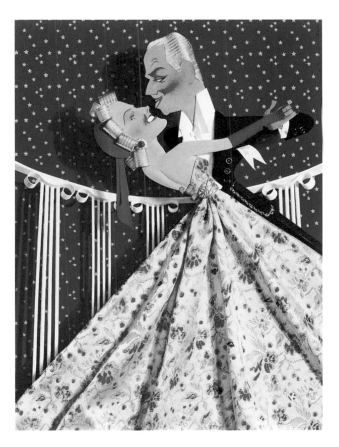

Woman of the Year
MGM, 1942

Together for the first time, Katharine Hepburn and Spencer Tracy are spotlighted in this collage that not only captures the distinctive features of the two powerhouse stars, but also the comedic yet sophisticated mood of the film.

We Were Dancing
MGM, 1942

Kapralik's elaborate collage for this stylish production incorporates a seemingly disparate mix of materials: lush brocade, white plastic, and gold foil set against a rich blue background flooded with silver stars. The caricatures of Norma Shearer and Melvyn Douglas plugged the film's deceptive title. (It was a romantic comedy, not a musical.)

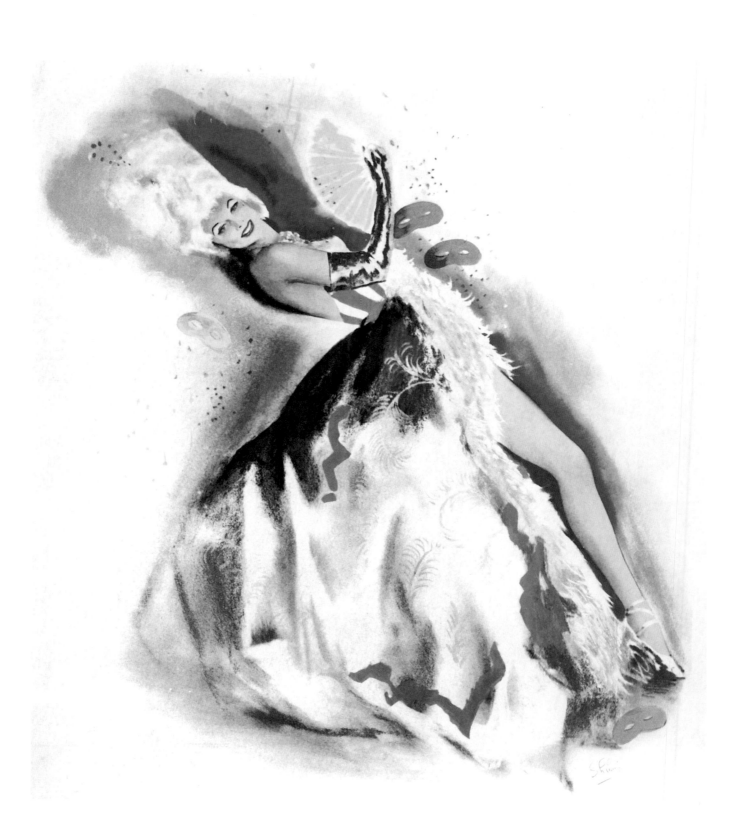

DuBarry Was a Lady

MGM, 1943

Symeon Shimin's extensive background as a theater lobby display artist is evident in his work for the Technicolor film adaptation of Cole Porter's stage hit. From her satin-toed slippers to her towering cloud of DuBarry hair, Shimin's showgirl, painted in a watercolor rainbow, is pure razzle-dazzle.

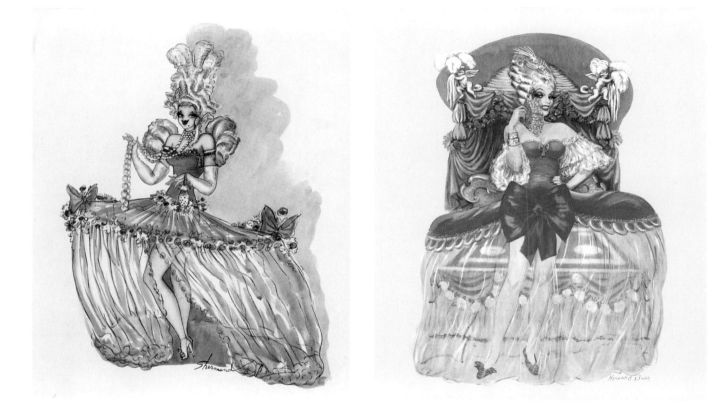

DuBarry Was a Lady
MGM, 1943

As part of MGM's exhibitor campaign for *DuBarry Was a Lady,* the studio commissioned two of *Esquire* magazine's leading artists to paint their impressions of the "DuBarry Girl." On the left is a DuBarry showgirl by watercolorist Helen Shermund. On the right is Howard Baer's inspired version. However, the DuBarry Girl most seen and used extensively in national advertising was the work of *Esquire*'s airbrush artist, Alberto Vargas.

Cabin in the Sky
MGM, 1943

Albert Hirschfeld vividly interprets the Broadway musical fantasy that depicts the forces of good and evil battling for the soul of a reformed gambler. The film's all-black cast featured Eddie "Rochester" Anderson, Ethel Waters, Lena Horne, Cab Calloway, Louis Armstrong, and a memorable score by Harold Arlen and E.Y. Harburg, the team that provided the unforgettable songs for *The Wizard of Oz*. *Cabin in the Sky* was filmed in black-and-white.

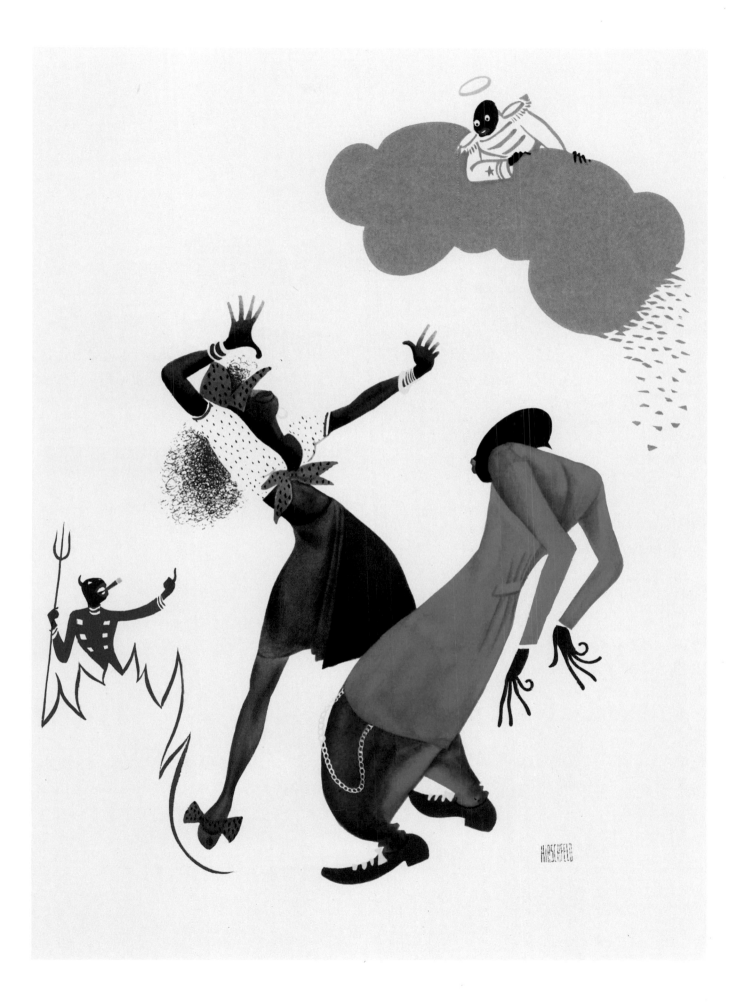

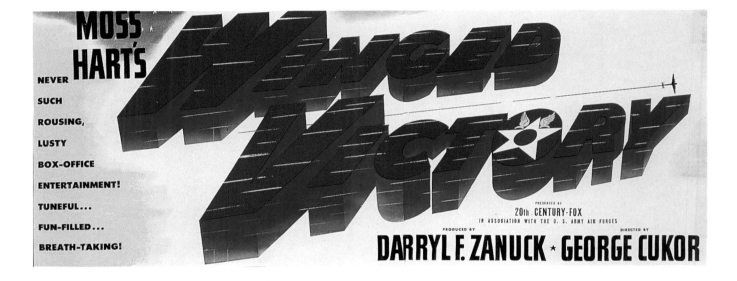

Winged Victory
Twentieth Century-Fox, 1944

Darryl F. Zanuck's production of Moss Hart's inspiring World War II Broadway hit (1943) literally takes flight in this highly patriotic elongated design. Windswept, italicized block letters in red and blue, slightly overlapping to convey strength and unity, are set against a pale blue sky. To further enhance the graphic for his story of hope and courage among men in the Air Force and their families, bold strokes of bright yellow border the edges. Many of the cast members—Pvt. Lon McCallister, Sgt. Edmond O'Brien, Cpl. Don Taylor, Cpt. Lee J. Cobb, Cpl. Red Buttons, T/Sgt. Peter Lind Hayes, and Cpl. Barry Nelson—were established actors on leave from the service to appear in the film.

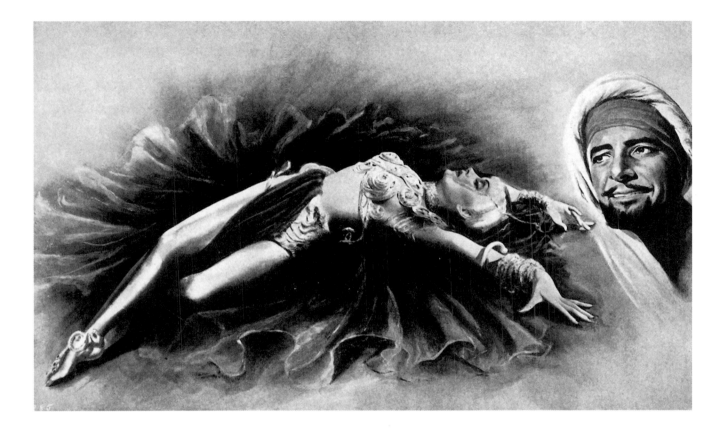

Kismet
MGM, 1944

Marlene Dietrich and Ronald Colman are rendered in black and white by an uncredited artist for the opulent Arabian Nights tale filmed in Technicolor. Dietrich is illustrated in the revealing and much-publicized costume that had her body covered with gleaming gold paint.

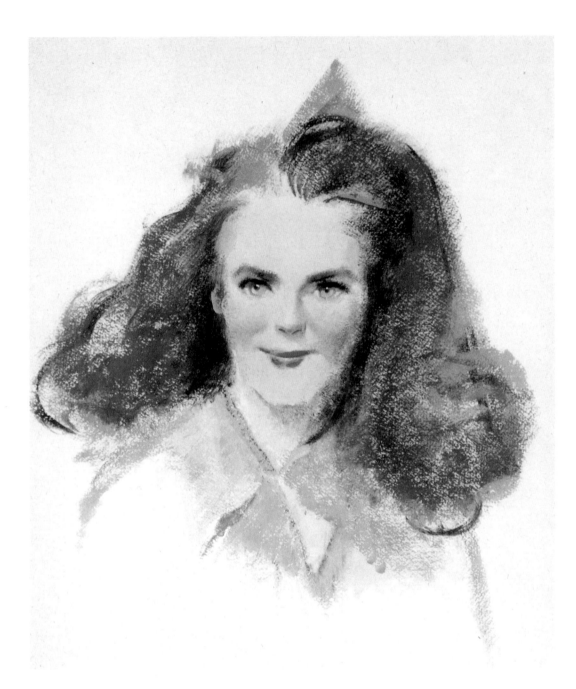

National Velvet
MGM, 1944

How can we forget Elizabeth Taylor as Velvet Brown in the movie that made her a star? Sketched in pastels on textured stock by an uncredited studio artist, the portrait's free-flowing strokes and expression convey the determination and eagerness of the horse-loving central character, whose dream is to ride her way into the famed Grand National Sweepstakes. The story was first intended for Katharine Hepburn at RKO, but Paramount purchased the rights. Unable to cast the young lead within the studio, Paramount sold the property in 1937 to MGM, where it sat idle until the "discovery" of Elizabeth Taylor years later.

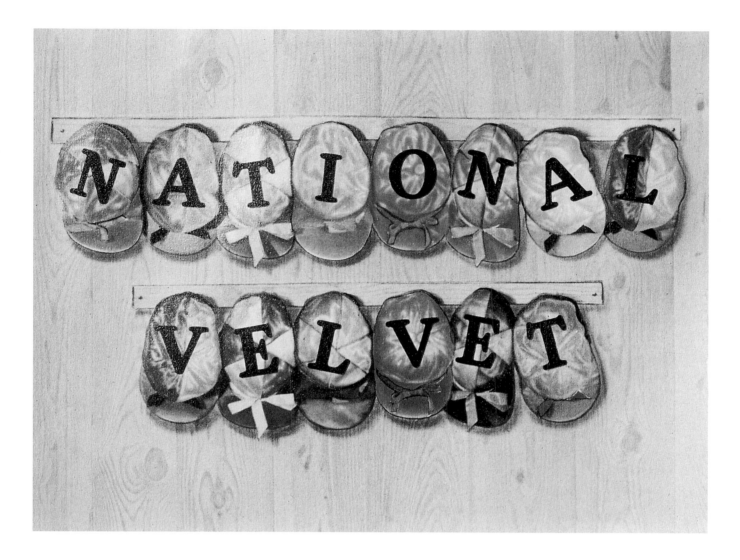

National Velvet

MGM, 1944

Another treatment focuses instead on the film's primary theme. The consistently high quality of work produced by the studio's art department, under advertising and publicity director Howard Dietz and art director Hal Burrows, is exemplified by this "poster look" ad for the filmed version of Enid Bagnold's bestselling 1930s family novel. Racks of jockey caps, showing their distinguishing racing colors, are superimposed with randomly tilted letters "in motion" that spell out the film's title.

Meet Me in St. Louis

MGM, 1944

Albert Hirshfeld interprets a scene from the now classic turn-of-the-century Technicolor musical, featuring stars Judy Garland, Tom Drake, and Margaret O'Brien. To lend additional authenticity and nostalgia, Hirshfeld included a framed pen-and-ink portrait in profile of the era's popular Gibson Girl.

Daily Variety, Jan. 3, 1945.

Meet Me in St. Louis

MGM, 1944

This alternate treatment combines colorful paper elements and hand-tinted photography. Although Jacques Kapralik continued to work for the studio beyond the Golden Age of Hollywood, it is doubtful this piece is his; more likely, it was made by an uncredited protege. While the piece possesses certain Kapralik touches, it is far too primitive in execution. Even so, it remains highly successful in reflecting the feel-good charm and mood of this long-adored film.

Cover Girl
Columbia, 1944

Rita Hayworth's 1941 *Life* magazine cover photo, showing her kneeling in bed wearing a form-fitting satin and lace negligee, boosted her popularity with G.I.s around the world and had her vying for number one pin-up girl with Betty Grable. As Fox celebrated Grable's great appeal with the wartime Technicolor musical *Pin-Up Girl* (1944), Columbia countered by starring Hayworth in the big-budget *Cover Girl*. The competition didn't end there. With a nod to Fox's earlier promotion for Grable in *Moon Over Miami*, Columbia similarly posed Hayworth. (For the consumer campaign seen by the general public, Hayworth also wore a red bathing suit.) The figure of Hayworth, however, was not airbrushed, but was instead executed with an innovative "fake color" process, devised several years earlier by the studio's art director, Jack Myers, and his successor, Jack Kerness. It was a process borne out of necessity, one that combined photography and art. Because color photography was still in its infancy, and artists seldom had a range of color shots from which to choose, they were able to expand their options by colorizing black-and-white photos. The process was so well received that other studios were soon using it. Hayworth is shown here in a pose from the studio's still department, along with other "cover girls," including supermodel Jinx Falkenberg in the lower right.

Coming..

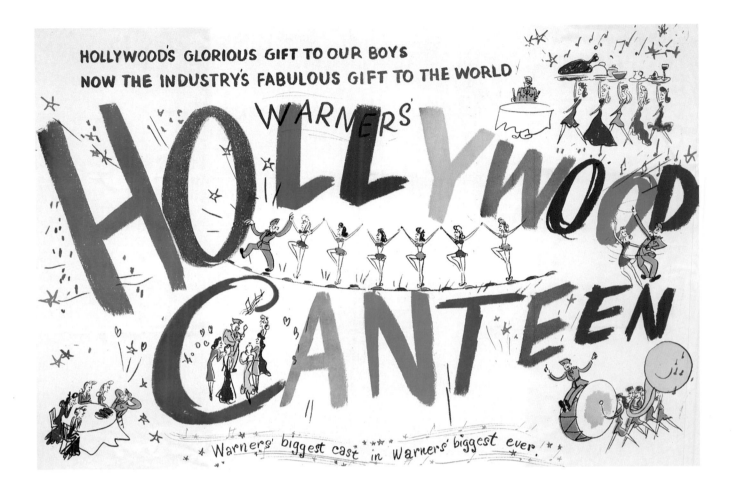

Hollywood Canteen
Warner Bros., 1944

Of all the studios, Warner Bros. had the most recognizable graphics. Characteristic of the "Warner's look"—and in contrast to the 1930s when the studio's ads reflected the dark, moody, often gritty themes of its films—were an abundance of white space, bold letters rendered in a contemporary brush stroke, and the minimal use of star illustrations. "Corporate identity was extremely important during the Golden Age," emphasized a rival art director. "Building an image was critical in attracting people to an MGM movie, a Zanuck presentation, one from Zukor at Paramount, and so on." At Warner's, color was seldom used, making the double-page art for *Hollywood Canteen,* the studio's splashy, all-star wartime musical filmed in black and white, something of a rarity.

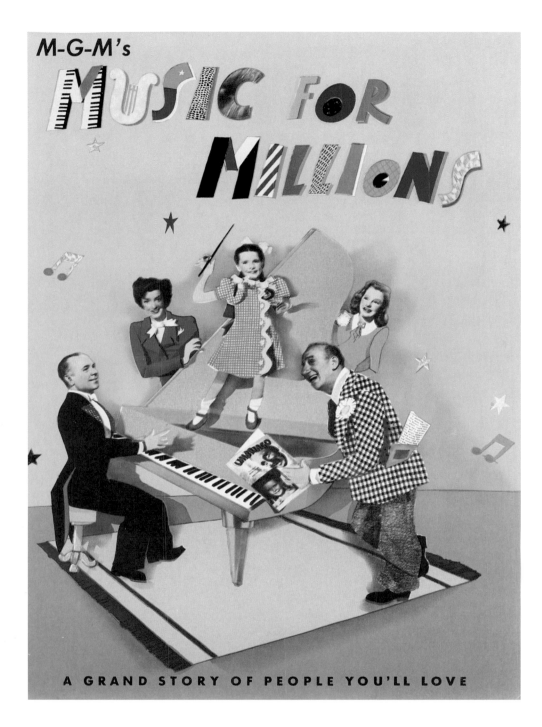

Music for Millions
MGM, 1944

For this sentimental wartime tale blending doses of classical music with soap opera, the studio released the least refined of its Kapralik-influenced collages. Making the movie appear to be more fun than it really was were paper doll cut-outs capped with tinted photographic images of the film's stars, Jose Iturbi, Marsha Hunt, Margaret O'Brien, Jimmy Durante, and June Allyson. Adding to the scissors-and-paste look are the multi-patterned letters that spell out the title.

The Purple Heart
Twentieth Century-Fox, 1944

A fictionalized account of American airmen shot down over Japan on a bombing raid, captured, and tried as war criminals and executed, is given strong treatment by award-winning illustrator Frederick ("Fritz") Siebel. Despite the grim storyline and Siebel's use of terrifying symbolic elements of the time (the rising sun, Mount Fujiyama, and the hovering presence of a Japanese official), the poster-like graphic conveys a sense of strength and hope without resorting to flagwaving.

Keep Your Powder Dry
MGM, 1945

For the story of three young women who join the WACs during World War II, collage master Jacques Kapralik was back in action, leaving little doubt that the film was a glamorous patriotic effort. His mini-waisted caricatures, constructed of fabric, fur, yarn, and jewels, depicted leading ladies Susan Peters, Laraine Day (with tie-in powder puff), and Lana Turner. *Keep Your Powder Dry* was filmed in black and white.

Along Came Jones
United Artists, 1945

Between assignments at the *Saturday Evening Post* and Twentieth Century-Fox, where he created theme art for *The Song of Bernadette* (1943) and *The Razor's Edge* (1946), illustrator Norman Rockwell faithfully captured Cooper's low-key but bigger-than-life appeal. The impish expression on Cooper's face, normally reserved for his roles in romantic comedies, helped set the tone for this mild Western spoof. Although Rockwell enjoyed great success, his style was better suited for *Post* covers than motion picture promotion. His covers displayed a broad range of emotions, from homespun humor to pathos, while his work for the movies was more limited, resulting in a sameness that was often static.

Meet Gary Cooper
...Melody Jones
...Gentleman Unafraid

Norman Rockwell

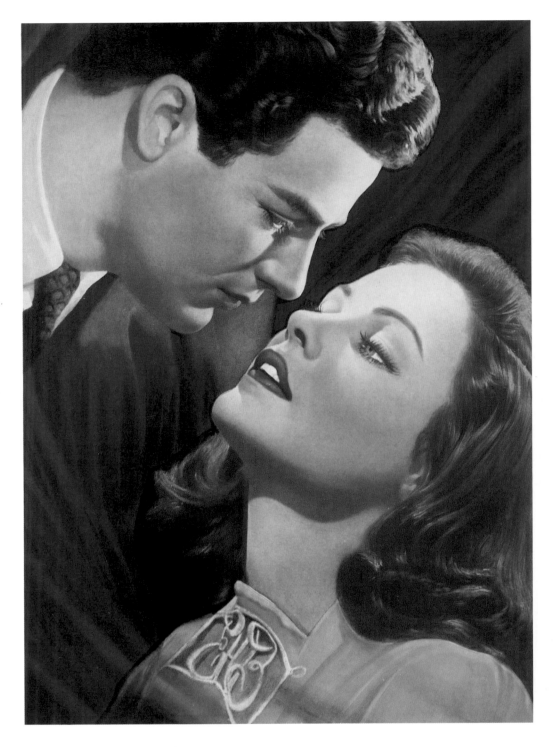

Leave Her to Heaven
Twentieth Century-Fox, 1945

The melodramatic story of a scheming, jealous woman obsessed with love for her husband is interpreted by an uncredited studio portrait artist. The central characters, portrayed by Cornell Wilde and Gene Tierney, are rendered in a slick, romanticized style, in keeping with the Technicolor film's rich production values.

Saratoga Trunk
Warner Bros., 1945

The distinctive "Warner Bros. look" of the 1940s was never more evident than in the space-filled, poster-style art for the filmed adaptation of Edna Ferber's best-selling novel. Hand-lettered brush strokes, a staple in the studio's ads, were repeatedly used to great effect for various releases— whether drama, action, comedy, or musical. It was during this period, however, that actors, producers, and directors began inserting billing clauses into their contracts, regulating the size of their names in relation to the film's title. The studio artists felt this development would restrict their creativity and therefore lower the quality of their work.

Diamond Horseshoe
Twentieth Century-Fox, 1945

C.C. Beall's dramatically hued watercolor smartly focused on the film's star, World War II pin-up queen and reigning box office champion, Betty Grable. Dressed in a whipped cream-colored production gown and posed like a cake ornament, Grable dominated the background elements, which included singing co-star Dick Haymes and lots and lots of curves. The jeweled horseshoe set at the lower right pays homage to Billy Rose's Diamond Horseshoe (the film's original release title), a famed New York nightclub where the musical takes place.

Marvelous, Marvelous, Marvelous in **THE CORN IS GREEN** another great play that **WARNERS** bring to the screen!

N.Y. HOLLYWOOD **NOW!**

BETTE DAVIS in "THE CORN IS GREEN" with JOHN DALL · JOAN LORRING · NIGEL BRUCE · RHYS WILLIAMS
Directed by IRVING RAPPER · Screen Play by Casey Robinson & Frank Cavett · From the Stage Play by EMLYN WILLIAMS · Produced by Herman Shumlin · Music by Max Steiner · Produced by JACK CHERTOK

The Corn Is Green
Warner Bros., 1945

Warner's splashy double-page graphics hammered home Bette Davis' potent star appeal. The sketchy, colorful, rather musicalesque crayon art and handlettered script are certainly eye-catching, but totally misleading in concept. The film itself, shot in black and white, concerned a prim schoolteacher in a dreary Welsh mining village.

Gilda
Columbia, 1946

Still photographer Robert Coburn posed glamorous Rita Hayworth in a sexy, strapless pale satin sheath by Jean Louis and had her drag a fur beside her to recreate a scene from the film. This shot is frequently mistaken as a still from the steamy "Put the Blame on Mame" number, in which Hayworth did a mock strip while wearing a black satin strapless dress with black opera-length gloves. Hayworth's provocative stance, knowing facial expression, slightly parted lips (as if she were about to blow smoke from the cigarette held high in her other hand), and luminous, backlit hair created an image that solidified her "love goddess" status. The striking black-and-white graphics, with subtle slashes of red and silver, were appropriate for the dark, brooding film noir look of the mid- to late 1940s.

Without Reservations
RKO, 1946

Twelve years after winning an Academy Award for best actress in Frank Capra's *It Happened One Night,* Claudette Colbert was starring in another cross-country romantic comedy. Her new movie had her cast as a best-selling novelist on her way to Hollywood to oversee the filming of her latest book. Along the way she meets a rugged Marine (John Wayne) who strikes her as the perfect "hunk" for her picture. Although the destination, mode of travel, and leading men were different, the similarities between the two Colbert films were not lost on the studio. Hoping some of the 1934 box-office magic would rub off on the new production, art director David L. Strumf and his staff created composite art that went so far as to revive memories of the famous hitchhiking scene in the Capra classic. Bold use of flat color in large areas contrasts effectively with the black-and-white retouched photographic images of Colbert, Wayne, and co-star Don DeFore.

Captain from Castile
Twentieth Century-Fox, 1947

Tyrone Power, as a dashing Spanish nobleman, and Jean Peters, as a peasant girl, are caught in a romantic moment by New York artist Gargink. The muted color portraits add another dimension to the sprawling and magnificent adventure epic, based on Samuel Shellabarger's historical novel. *Captain from Castile* was filmed in Technicolor on location in Mexico.

Shirley is whirley about
the Guy who gives the girls
a big romantic bang!...
...in RKO's

HONEYMOON

Honeymoon
RKO/Vanguard, 1947

The problems grown-up Shirley Temple encounters in eloping to Mexico to marry her soldier boyfriend (Guy Madison) are the basis for this romantic comedy. By using a whimsical cartoon approach to the art—uncredited but probably the work of caricaturist Abe Birnbaum—the artist had the flexibility to incorporate various plot points with a simple line or dash of color. The film was adapted from a story by novelist Vicki Baum, author of *Grand Hotel*.

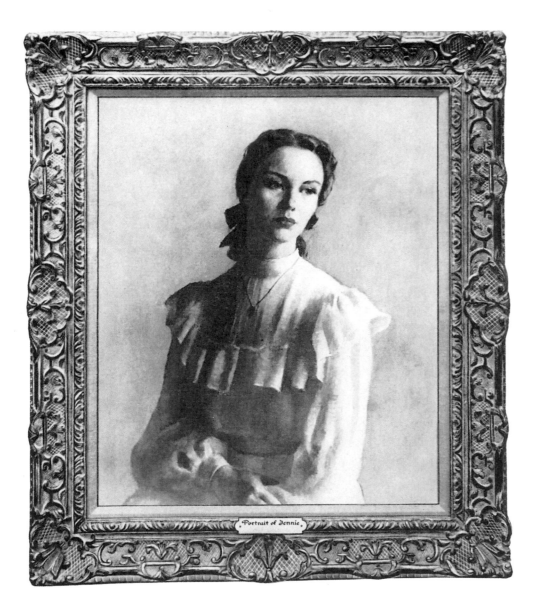

Portrait of Jennie
Selznick, 1948

The fragile beauty of Jennifer Jones was painted on canvas by artist Robert Brackman for this romantic black-and-white fantasy (with color end sequence) based on Robert Nathan's novella. The film's opening narration tells of "the haunting legend of a painting…which hung in the Metropolitan Museum in New York. . . ." Prior to the movie's completion, it was announced that Brackman's portrait of the fictional Jenny had been chosen for exhibition at the Metropolitan. The framed portrait was used extensively in the studio's promotion to the exhibitors.

Red River
United Artists, 1948

Howard Hawks' sprawling landmark Western about a cattle drive along the Chisholm Trail was treated to a two-color billboard-style ad. The piece's wall-to-wall use of space includes a panoramic montage of action/adventure scenes from the film. A blazing arrow slashing across the page heightens the sense of danger. Although the two stars, John Wayne and Montgomery Clift, are listed in small type, their images are not shown.

Joan of Arc
RKO, 1948

Hoping to sell the film on its two greatest assets—Ingrid Bergman and stunning Technicolor cinematography—the studio showcased its star using an actual production still. Bergman, as the Maid of Orleans, in full armor and astride a horse, appears gallant despite the somber blue tones that impart an appropriate sense of doom.

JOAN OF ARC

starring INGRID BERGMAN

COLOR BY TECHNICOLOR

The Big Clock
Paramount, 1948

This taut thriller features a diabolical newspaper publisher (Charles Laughton) who commits a murder and then, knowing all clues point to his top reporter (Ray Milland), assigns him to solve the crime. Combining art with photography, an uncredited studio illustrator shows Milland twice, once in a head shot (being watched by Laughton, coarsely screened and toned, as if lurking in the shadows), and again in a full-figure crouched position, appearing like a man on a tightrope. Is time his ally—or his enemy?

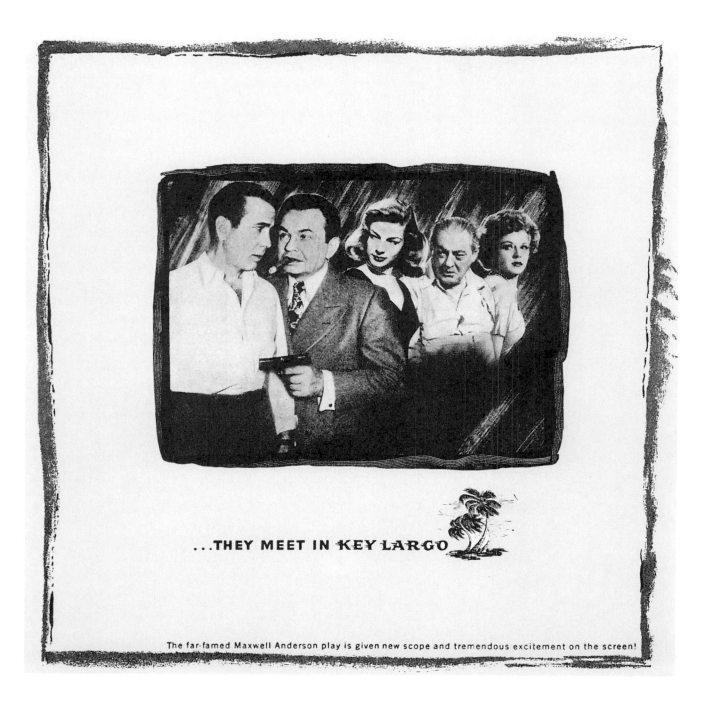

...THEY MEET IN KEY LARGO

The far-famed Maxwell Anderson play is given new scope and tremendous excitement on the screen!

Key Largo
Warner Bros., 1948

Who can forget this moody melodrama about a returning war veteran (Humphrey Bogart) pitted against a tough gangster (Edward G. Robinson) in the Florida keys? The stark black-and-white photo collage, showing Bogart, Robinson, and co-stars Lauren Bacall, Lionel Barrymore, and Claire Trevor (who won Best Supporting Actress honors), is placed against a background of diagonal slash strokes, representing the raging storm sequence. Additional symbolism is achieved by the surrounding box, which lends a note of entrapment.

An Ideal Husband
Korda/Twentieth Century-Fox, 1948

Looking like a page from *Vogue* or *Harper's Bazaar*—where Hungarian high fashion artist Marcel Vertès worked for a time—this elegant, stylized watercolor illustrates a single female figure swathed in yards of flowing fabric. The dramatic free-flowing art, which bears no resemblance to the film's star, Paulette Goddard, was used as theme art for this adaptation of Oscar Wilde's classic (and classy) drawing room comedy. *An Ideal Husband* was filmed in Technicolor.

"*An Ideal Husband*
has to think of
his future.......
A woman has to
think of her past!!!!"

Verties

Bagdad
Universal-International, 1949

In the 1930s, romantic South Sea island adventure movies captured the public's imagination. The setting changed in the 1940s, and for more than a decade tales of Arabian Nights starred such film favorites as Maria Montez, Turhan Bey, Sabu, Jon Hall, and even Tony Curtis. Typical of promotion for the genre is the full-color graphic for *Bagdad* with its sun-washed sands, star-filled sky, legions of daring warriors in Bedouin robes, and the seductive, scantily clad desert beauty.

Part Four

From the Golden Age to Today

The Fifties

The inroads being made by the fledgling television industry were bringing Hollywood to its knees. The moviegoing public was fascinated by the small screen, despite the fact that it had little to offer viewers. Staying home, rather than going out to the movies, was fast becoming a habit with once-loyal film fans. To make matters worse, the studios had been forced by antitrust law to sell their chains of theaters and to subsequently stop "block booking." No longer would they have automatic venues to show their products.

Sweeping cost-cutting measures were enacted. Production budgets were lowered, staffs trimmed, and stars released from their contracts. Then, the unthinkable happened. Needing cash, RKO sold its television rights to over 700 old films. Other studios followed.

Something had to be done to lure moviegoers back to the theaters. The solution came in the rebirth of the spectacle—lavish musicals and epic dramas with casts of thousands, shown as never before seen on gigantic, wide screens. Ads promoted the latest in technological advances: CinemaScope, VistaVision, Cinerama, Todd-AO, and 3-D, along with stereophonic sound. Color, too, was hyped, a slap in the face at then black-and-white-only TV. Seeing a movie became an experience that could never be duplicated at home. "Movies are better than ever!" cried Hollywood.

The promotional artwork of the time reflected Hollywood's renewed approach to selling its movies which, as an added lure, included "adult" themes that were unthinkable for television. Among the artists, Saul Bass became a force by setting a new trend in graphics. Beginning in the fifties, his revolutionary feature film credits and logos provided strong identification for such motion pictures as *Carmen Jones* (1955), *The Seven Year Itch* (1955), *The Man With the Golden Arm* (1956), *Around the World in 80 Days* (1956), *Vertigo* (1958), *Bonjour*

Tristesse (1958), and *North by Northwest* (1959). Bass' philosophy held that "the first frame of film is *the* first frame of the film—and the film begins there."

Other notable illustrators and designers of the decade included Neil Boyle, Fred Hatser, Jacques Kapralik, Ren Wicks, Jon Whitcomb, and Bessor. Many of the best promotional illustrations were made for *The Egyptian* (1954), *Silk Stockings* (1957), *The Inn of the Sixth Happiness* (1958), *The Fly* (1958), *Last Train from Gun Hill* (1959), *Ben-Hur* (1959), and *Gone With the Wind* (1959 reissue).

The Sixties

A decade of violent changes rocked the film industry: the continuing decline of the star system and its influence on advertising; the rise of independent producers and production companies; the re-emergence of the director (Alfred Hitchcock and Federico Fellini, among others) as a vital sales feature; and the demise of the old Production Code, known as the Hays Office, which was replaced by a new film rating system that opened the way for more permissiveness in subject matter and treatment. "It is not simply that the movies have changed," commented noted film critic Charles Champlin. "We have changed and the world has changed. They don't make movies the way they used to because the world isn't the way it used to be."

It was also a period that saw an outpouring of distinguished graphic design, which helped keep Hollywood's products alive despite the closing of in-studio creative art departments. The void was capably filled by a rise in independent artists and designers. The use of photography became increasingly popular as a design element. As one

illustrator noted, however, "It doesn't really matter whether an assignment is done by the artist or the camera. The point is, is the work illustrated properly? Is there an idea in the illustration?"

Other changes included advances in techniques and materials, such as air brushing, mezzo tinting, and double printing. Because advertising art of the sixties truly blended the best of all print media techniques, it was a significant force in keeping Hollywood's light burning. Long overdue, the creators of movie advertising began to receive recognition with the establishment of the Annual Motion Picture Advertising Awards, sponsored by the B'Nai B'Rith Cinema Lodge of New York.

One of the bright, new talents on the scene was Robert Peak. Trained at Art Center of Los Angeles, he soon became a wunderkind with his striking montages and graphics for such films as *West Side Story* (1961), *My Fair Lady* (1964), and *Camelot* (1967). Saul Bass added his brilliant logos to *Psycho* (1960), *Exodus* (1960), *Spartacus* (1960), *Walk on the Wild Side* (1962), *It's a Mad Mad Mad Mad World* (1963), *The Cardinal* (1963), *Seconds* (1966), and *Grand Prix* (1966). Norman Rockwell was commissioned for a series of star sketches for the remake of *Stagecoach* (1966), and Dong Kingman created a magnificent watercolor for *Flower Drum Song* (1961). Also making major contributions were Don Record, Rod Dyer, Robert Tannenbaum, M. Hooks, Reynold Brown, and Randall Enos.

The Seventies

Box office grosses climbed despite lower attendance at movie theaters. Hollywood was in the midst of a resurgence, thanks to higher

ticket prices and an influx of younger audiences, who were tiring of lackluster television fare. The draw for the newer moviegoers was a heavy emphasis on risqué and violent themes, along with sequels to earlier favorites.

In advertising, the trend moved away from magazines to newspapers and television. "We must remember," said one studio art director, "that motion picture advertising is retail advertising. Whether it's going to Macy's, Bergdorf-Goodman, or the movies, people consult their newspapers for information. And they are led to the paper by television, which is a marvelous medium for frequency and reach. The ad may say, 'coming to a theater near you.' Where? 'Check your local newspaper listing.' That information can really only be found in one place. Print by its very nature is an information base."

Without a true star system, and a general lack of star drawing power, ads tended not to show players' names. The emphasis was on theme art, title of film, and copy lines. Despite continuing advances, the illustrator did not become a casualty to technology, as reported in a prominent graphics trade magazine. To the contrary, the illustrator not only survived, but flourished. Much of the finest work continued to appear in Hollywood trade publications, though less frequently than in earlier days.

The descriptive art and dynamic title logo for *The Poseidon Adventure* (1972) gave claim to one of the best overall print campaigns of the decade. Other noteworthy pieces promoted *Cabaret* (1972), *The Day of the Locust* (1975), *Funny Lady* (1975), *The Missouri Breaks* (1976), *Logan's Run* (1976), *Rollerball* (1977), *Superman* (1978), *Heaven Can Wait* (1978), *All That Jazz* (1979), *Apocalypse Now* (1979), and *Manhattan* (1979). Among the top illustrators were Tom Young, Robert Peak, Frank Frazetta, Laurence Salk, Wilson McLean, James

Dietz, Mark English, Ted C. CoConis, Jack Neal Unruh, Isadore Seltzer, David Grove, John Berkey, Richard Amsel, Bernie Lettick, and Doug Johnson.

The Eighties

A continuing trend toward big-budget "event" films, with an emphasis on erotic thrillers, action, and special effects, was reflected in advertising campaigns that were more competitive and direct in content. "It's crotch time," became a common cry, as good taste too often succumbed to a lower level of creative subject matter. Sex, on the screen and in the ads, was commonplace and, in many instances, a necessity to draw customers.

The rising cost of doing business within the industry had executives looking carefully at how dollars were spent. Smaller numbers of on-staff creative personnel meant that studios were working primarily with outside graphic specialists—from freelance art directors to illustrators, designers, and photographers. It was a far cry from the old days when "the studio" was strictly in control. Now it had broadened to dealing with independent producers and production companies working under the umbrella of the studio. Said Twentieth Century-Fox executive Ken Markman, "The approval process for illustrators and designers has become so cumbersome and convoluted and pressure-oriented, I liken the phenomenon of getting an ad through to beginning with a glacier and ending up with a snowball—if you're lucky. The cleanliness of an original idea is directly proportionate to the number of hands that idea must go through." Those hands included everyone from the investors, producer, and production com-

pany, to the writer and director, *plus* the corporate president, senior management, production management, legal personnel, agents, and business managers. It wasn't always that way.

During the Golden Age of movies, the studios were turning out twenty movies a month, and many decisions were made by one or two people. It was basically routine to walk in the door with questions, and walk right out the following minute with answers to every one of them. In the years that followed a multitude of doors were added to the procedure. As a result, some of the very best work never saw the light of day.

The ensuing years also made it more difficult for an illustrator to receive name recognition for his or her work. Certainly, the signatures of fewer artists were seen on illustrations. By the eighties, promotional artwork had become collaborative, a potpourri consisting of a photo by one person, illustration by another, and logo and copy lines by still others. The process has been described as "a concert," conceived and executed by many artists.

Among the busiest illustrators of the decade was John Elvin, whose first assignment for *E.T. The Extra Terrestrial* (1982) was followed by another for *Victor/Victoria* (1982), as well as for *Blade Runner* (1982), *Cocoon* (1985), *Empire of the Sun* (1987), and *Rain Man* (1988). "*Cocoon* was very difficult," said Elvin. "I couldn't show the very charm of the movie—the older actors—because they might not appeal to younger audiences."

Other top artists of the eighties included Robert Peak, Roger Ruyssen, Dan Gozée, Drew Streuzan, and Richard Amsel, who had developed a "movie look" other illustrators would strive to achieve even years later. Outstanding promotional artwork was created for *The Stunt Man* (1980), *Bronco Billy* (1980), *Heaven's Gate* (1980), *Tattoo*

(1980), *Excalibur* (1981), *Raiders of the Lost Ark* (1981), *Deathtrap* (1982), *Star Trek II: The Wrath of Khan* (1982) and *Indiana Jones and the Temple of Doom* (1984).

The Nineties

These days, summer sequels make box office magic along with dark-horse films, which seemingly come out of nowhere to become huge hits. Criticism of extreme on-screen violence has generated a surge of romantic comedies and children's fare, led in large part by Disney. Strong, too, are "big pictures" with fairy tale characters, comic book heroes, and special effects, along with remakes of classic TV series.

Recent promotional illustrations have continued the creative concepts from the eighties, relying heavily on the use of photographs, particularly of emerging stars, satisfying—if only temporarily—the moviegoer's hunger for fresh, new faces.

The creative process has become more collaborative than ever and, because of digital technology, more confusing. It has been said that the technology has overshadowed traditional concepts. Today's top illustrators include John Elvin, Drew Streuzan, Dave Christianson, Steve Chorney, and Thomas Blackfoot. Some of the best promotional artwork from the early decade was created for *Dick Tracy* (1990), *Beauty and the Beast* (1991), *The Silence of the Lambs* (1991), *The Rocketeer* (1991), *Jungle Fever* (1991), *The Addams Family* (1991), *Aladdin* (1992), *Batman Returns* (1992), *Sabrina* (1994), and *The Lion King* (1994).

Part Five

The Artists

The work of the artists profiled below comprises the majority of the visuals featured in *The Lost Artwork of Hollywood*. The great variety of techniques, diversity of styles, and high quality of work from Hollywood's Golden Age made the process of selecting pieces for this book quite a challenge, especially in light of their having been buried for so many years, unseen by the public.

Because many of these artists worked entirely behind the scenes, skillfully creating the promotional images that inspired exhibitors to get movies into theaters in the first place, I have tried to give them the recognition they so deserve, however belatedly. Regretably, there are several artists noted in the text who are missing here. No amount of digging or sleuthing was enough to uncover the professional highlights of these talented artists and designers; too little is known about them to include them in this summary, and a number of them—staff artists working in studio art departments—never received name credit or attribution of any kind for their valuable contributions. The inclusion of their work in these pages is the only tribute I can offer.

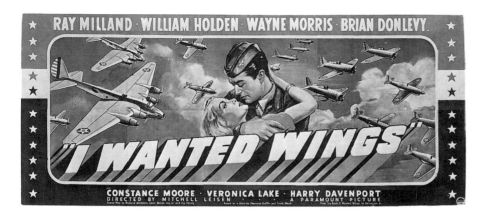

McClelland Barclay,
billboard, 1941.

Howard Baer

Cartoonist, illustrator. A New Yorker, Baer worked primarily for *Esquire* and *The New Yorker* magazines, which regularly featured his cartoons showing voluptuous women, often in suggestive situations. He was commissioned by MGM for a special trade campaign to promote the studio's musical comedy *DuBarry Was a Lady* (1943).

McClelland Barclay

Editorial illustrator, advertising artist. Barclay was generally known for his paintings of strikingly beautiful women, as exemplified by his series for General Motors which visualized the slogan "Body by Fisher." He created many posters, illustrations, and officer portraits for the U.S. Navy before being reported missing in action in the Pacific during World War II. He also worked on various film campaigns for Paramount, RKO, and Twentieth Century-Fox, including *From Hell to Heaven* (1933), *Artists and Models* (1937), *Hotel for Women* (1939), *No No Nanette* (1940), and *I Wanted Wings* (1941).

Cecil Calvert Beall

Illustrator, portraitist. The bold poster style of Beall's early watercolors, with its highly contrasting lights and shadowy darks, first brought him attention as a magazine illustrator. His cover portrait of President Franklin D. Roosevelt for *Collier's* resulted in his appointment as Art Director for the Democratic National Committee, and earned him additional covers depicting decorated World War II heroes. In Hollywood, RKO and Twentieth Century-Fox commissioned him for such films as *Government Girl* (1943), *Diamond Horseshoe* (1945), and *China Sky* (1945).

Abe Birnbaum

Caricaturist, illustrator. A frequent contributor to *The New Yorker* and *Harper's Bazaar*, this New York-born artist was highly sought after for his light, often comedic style and versatility. His work for films included trade ads for *Love on the Run* (1936) and *Honeymoon* (1947).

Robert Brackman

Painter, portraitist. A widely exhibited Russian-born artist, Brackman was expressly commissioned to paint the ethereal portrait of Jennifer Jones for David O. Selznick's fantasy *Portrait of Jennie* (1948).

Benton Clark

Painter, illustrator. Clark trained at the Art Institute of Chicago and the Art School of the National Academy of Design in New York. His dramatic, colorful scenes of the Old West brought him to the attention of MGM, where he spent his early years in the art department creating visuals for frontier dramas such as *Cimarron* (1931) and later, at RKO, *Tall in the Saddle* (1944). He ultimately illustrated for most major magazines, including *The Saturday Evening Post, Cosmopolitan, McCall's,* and *Good Housekeeping.*

William Galbraith Crawford

Illustrator, cartoonist. Crawford was best known for his subtly humorous magazine covers (*The New Yorker* and *The Saturday Evening Post,* among many) and his widely syndicated panel cartoon, "Side Glances," all signed "Galbraith." His many credits as a poster artist were the high points of his prolific career. As a major contributor to MGM's national campaigns for nearly twenty years, he created illustrations for such films as *Ben Hur* (1926), *Anna Christie* (1930), *Red*

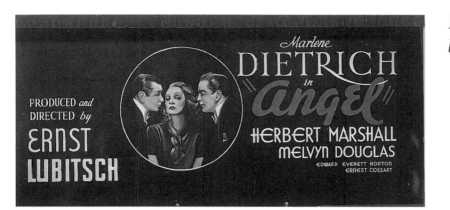

*Hans Flato,
billboard, 1937.*

Dust (1932), *Grand Hotel* (1932), *Dinner at Eight* (1933), *The Thin
Man* (1934), *Mutiny on the Bounty* (1935), *Naughty Marietta* (1935),
and *For Me and My Gal* (1942).

Carl Oscar August ("Eric") Erickson

Illustrator. American-born and trained, Erickson ultimately spent
much of his life in Paris, which he considered his second home.
Eric, as he signed his work, dominated the field of international
fashion illustration for over three decades. Typical of his sophisti-
cated style was a watercolor of Marlene Dietrich wearing a dra-
matic fur-trimmed evening coat and gown for Alexander Korda's
Knight Without Armour (1937).

Hans Flato

Illustrator, painter. Hired by Paramount in the early 1930s, the Euro-
pean-born artist worked almost exclusively on visuals for Marlene
Dietrich films. Among them were *Blonde Venus* (1932), *The Scarlet
Empress* (1934), *The Devil Is a Woman* (1935), and *Angel* (1937).

Anton Grot

Illustrator, set designer. The multi-talented artist began his film career
in 1913 painting backgrounds and designing sets. In 1927, he was
named head of Warner Bros.' set department, a position he held for
over twenty years. As an illustrator, he contributed to such cam-
paigns as *Robin Hood* (1922) and *The Thief of Bagdad* (1924).

Albert Hirschfeld

Caricaturist, illustrator. Before gaining universal acclaim for his witty,
highly distinctive, and instantly recognizable pen-and-ink show

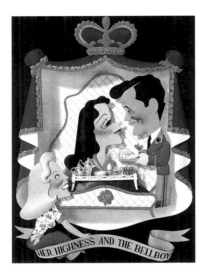

Jacques Kapralik,
trade advertisement, 1945.

business caricatures (in describing his genre, he once dismissed the word "caricature,"saying, "it has become a denigrating term"), Hirschfeld studied painting in Paris and turned out promotional visuals for the art departments at Warner Bros. and MGM. Working with a full palette of color rather than stark black and white, his style was not as identifiable then. His MGM portfolio in particular is filled with an impressive array of commissioned movie posters and exhibitor visuals for such features as *Bringing Up Father* (1928), *Min and Bill* (1930), *A Night at the Opera* (1935), *A Day at the Races* (1937), *Cabin in the Sky* (1943), and *Meet Me in St. Louis* (1944).

Ted ("Vincentini") Ireland

Illustrator, portraitist. When the subject is glamour portraits, few artists surpass the man who signed his work "Vincentini." At MGM, the studio known for its weighty roster of luminous stars, he became the specialist in capturing the glamour and appeal of such Golden Age greats as Greta Garbo, Myrna Loy, Jean Harlow, Norma Shearer, Hedy Lamarr, and so many others. His lengthy list of film credits includes *Anna Karenina* (1935), *After the Thin Man* (1936), *Libeled Lady* (1936), *Romeo and Juliet* (1936), and *The Women* (1939).

Jacques Kapralik

Caricaturist. The movies' premiere caricaturist, Kapralik assembled bits and pieces of straw, felt, yarn, satin, and more to create highly imaginative collages depicting stars in settings appropriate to their latest films. Because much of his work was trade-oriented, he was virtually unknown outside the motion picture industry. Inside, however, he was a wonder. He was at Paramount and Twentieth

John Lagatta,
trade advertisement, 1939.

Century-Fox in the thirties, yet his most notable output was for MGM during the following two decades. Among his credits are *Honky Tonk* (1941), *Woman of the Year* (1942), *Random Harvest* (1942), *Teahouse of the August Moon* (1956), *Designing Woman* (1957), and *Silk Stockings* (1957).

John Lagatta

Illustrator. Known primarily as a "women's artist," the Italian-born illustrator was one of the best known, most prolific, and highest paid artists of the thirties. His serene, understated style, drawn from his early experience as a fashion illustrator, made him a favorite of women's magazines and, in time, movie advertising, especially for love-themed stories. His artwork for *Intermezzo* (1939) helped to introduce Ingrid Bergman to American audiences.

Ronald McLeod

Illustrator. A self-taught Midwesterner, McLeod began illustrating for *Collier's* in 1928. His distinctive use of transparent watercolor earned him not only many covers and jobs at other popular publications of the day (*Cosmopolitan*, *American*, and *Pictorial Review*), but also listings in several editions of "100 Best Posters of the Year." In Hollywood, he was commissioned for various Paramount posters and film ads, as well as, for United Artists' *Vogues of 1938* (1937).

Lionel S. Reiss

Painter, portraitist. The Austrian-born artist spent his early years (1920 to mid-1930s) in Hollywood creating star portraits, sketches, and promotional illustrations for Paramount, Goldwyn, and other studios. He later settled in New York.

Norman Rockwell

Painter, illustrator. Norman Rockwell is perhaps America's most beloved illustrator. His work has been seen by more people than that of any other artist thanks to his long association with *The Saturday Evening Post*. It lasted over forty years, during which time he produced more than 300 covers. His warm, homespun style and consummate skill as an artist was also seen in posters, calendars, books, and advertising campaigns, including specially commissioned projects for the movies. His film credits include *The Adventures of Marco Polo* (1938), *The Song of Bernadette* (1943), *Along Came Jones* (1945), and *The Razor's Edge* (1946).

William Rose

Illustrator. A native of Pennsylvania, who studied at the University of Pittsburgh, Rose went on to become one of Hollywood's most requested illustrators of the thirties and forties. His creative output for Paramount, MGM, and RKO includes *An American Tragedy* (1931), *The Trail of the Lonesome Pine* (1936), *Vivacious Lady* (1938), *Citizen Kane* (1941), and *Suspicion* (1941).

Hy Rubin

Cartoonist, illustrator. New York artist Hy Rubin's delicate line drawings for *Good Housekeeping* during the thirties brought him to the attention of Hollywood's art directors.

Barbara Shermund

Cartoonist, illustrator. Shermund was a leading artist with *Esquire* magazine and one of the few successful female illustrators during the 1930s and 1940s. She was commissioned by MGM to provide her interpretation of "The DuBarry Girl" for the exhibitor advertising campaign to promote the studio's *DuBarry Was a Lady* (1943).

Symeon Shimin

Illustrator, painter, muralist. Shimin's striking use of design and color in displays and posters for the lobbies of New York's theater district attracted the attention of MGM's art directors, resulting in numerous freelance assignments for the studio over nearly two decades, beginning in the mid 1930s.

Frederick ("Fritz") Siebel

Caricaturist, painter. Born in Austria, Siebel worked almost exclusively for Paramount during the thirties and received numerous awards for his artistic achievements. He later moved on to do freelance work at Twentieth Century-Fox and other studios. To his credit are illustrations for such films as *Every Day's a Holiday* (1937), *College Swing* (1938), *The Big Broadcast of 1938* (1937), and *The Purple Heart* (1944).

*Alberto Vargas,
poster, 1933.*

Emmett O. Smith

Painter, illustrator. This highly regarded New York artist was known for his detailed, atmospheric paintings, which were frequently used to illustrate romantic fiction of the twenties.

Gustaf O. Tenggren

Illustrator, animator. A Swedish-born artist known primarily for his imaginative drawings for children's books, Tenggren served as an animator and illustrator for several Disney features beginning with *Snow White and the Seven Dwarfs* (1937).

Alberto Vargas

Illustrator. Peruvian-born and educated in Switzerland, Vargas became a household name when he replaced George Petty at *Esquire* in the early forties as the illustrator of long-limbed, sensuous pin-ups that came to be known as "the Varga Girl." During the twenties, he painted Ziegfeld Follies girls in various poses, and supplied figure studies for magazines, advertisements, sheet music covers, and brochures. He also fulfilled personal commissions for portraits, including such celebrities as Billie Burke and Norma Talmadge. The thirties found him not only as a set designer at Warner Bros., but also as an illustrator for movie posters and star portraits. He went on to contribute to the advertising campaigns at Warner Bros., Goldwyn, Twentieth Century-Fox, Universal, and Paramount for *Ladies They Talk About* (1933), *Nana* (1934), *Moon Over Miami* (1941), *Flame of New Orleans* (1941), and *Suddenly It's Spring* (1946).

Marcel Vertès

Painter, designer. This Hungarian-born artist's flowing, imaginative watercolors were published in *Vogue* and *Harper's* to great popularity. During the thirties, he began turning to illustrating exhibits and national advertising for various film studios. In 1952, he won two Academy Awards, one for Best Costume Design (color) for *Moulin Rouge* and a second, shared with Paul Sheriff, for Best Art Direction (color) on the same film.

Harry Alan Weston

Painter, teacher. An artist at an early age, Weston began illustrating promotional materials for the movies while in his twenties, specializing in dramatic adventure themes. His bold style was especially suitable for cliffhanger serials.

Jon Whitcomb

Illustrator. Born in Weatherford, Oklahoma, and raised in Wisconsin, Whitcomb made a name for himself with dreamy illustrations of young love and glamorous, beautiful women, often sprinkled with a scattering of stars, that ran primarily in *Collier's* and *Good Housekeeping*. *Cosmopolitan* featured his by-lined monthly series of sketches and articles about motion picture personalities, entitled "On Location with Jon Whitcomb." His illustrations for films include a starry-eyed portrait of Leslie Caron for *The Glass Slipper* (1954) and *Sayonara* (1957).

Ren Wicks

Illustrator, designer. A New York native, Wicks studied at Art Center College of Design and Kann Institute in Los Angeles. During World War II he was involved in the production of instructional handbooks for pilots of Lockheed's P-38 fighter and Hudson bomber. Following the war, he continued to produce projects for the aerospace industry and illustrations for magazine advertisements. One of a series of personal commissions for Howard Hughes had him rendering the famous pose of Jane Russell for her screen debut in *The Outlaw* (1943). He also created promotional art of Joan Fontaine for *Born To Be Bad* (1950), along with numerous stamp designs for the U.S. Postal Service, among them the "crossed flags" stamp for America's bicentennial.

Ren Wicks, billboard, 1943.

Bibliography

Basten, Fred. *Glorious Technicolor: 80th Anniversary Edition*. Burbank: Technicolor, 1994.

Basten, Fred. *Glorious Technicolor: The Movies' Magic Rainbow*. Cranbury, New Jersey: A.S. Barnes, 1980.

Baxter, John. *Hollywood in the Thirties*. Cranbury, New Jersey: A.S. Barnes, 1968.

Bergan, Ronald. *The United Artists Story*. New York: Crown, 1986.

Brown, Gene. *Movie Time*. New York: Macmillan, 1995.

Croce, Arlene. *The Fred Astaire and Ginger Rogers Book*. New York: Dutton, 1972.

Eames, John Douglas. *The MGM Story*. New York: Crown, 1979.

Eames, John Douglas. *The Paramount Story*. New York: Crown, 1985.

Eckersley, Tom. *Poster Design*. London and New York: Studio Publications, 1954.

Findler, Joel W. *The Hollywood Story*. New York: Crown, 1988.

Friedman, Joseph S. *History of Color Photography*. Boston: American Photographic Publishing Co., 1944.

Gabor, Mark. *The Pin-Up*. New York: Bell/Crown, 1972.

Griffith, Richard, and Mayer, Arthur. *The Movies*. New York: Simon & Schuster, 1957.

Haver, Ronald. *David O. Selznick's Hollywood*. New York: Knopf, 1980.

Higham, Charles, and Greenberg, Joel. *Hollywood in the Forties*. Cranbury, New Jersey: A.S. Barnes, 1968.

Hirschhorn, Clive. *The Hollywood Musical*. New York: Crown, 1981.

Hirschhorn, Clive. *The Universal Story*. New York: Crown, 1983.

Jacobs, Lewis. *The Rise of American Film*. New York: Harcourt, Brace, 1939.

Jewell, Richard B., and Harbin, Vernon. *The RKO Story*. New York: Crown, 1982.

Katz, Ephraim. *The Film Encyclopedia*. New York: HarperCollins, 1994.

Kobal, John. *The Art of the Great Hollywood Portrait Photographers*. New York: Knopf, 1980.

Lloyd, Ann, and Robinson, David. *The Illustrated History of the Cinema*. New York: Macmillan, 1986.

Lloyd, Ann, and Robinson, David. *Movies of the Forties*. London: Orbis, 1982.

Manwell, Roger. *Love Goddesses of the Movies*. New York: Crescent Books, 1975.

Monaco, James. *The Encyclopedia of Film*. New York: Perigee/Putnam, 1991.

Morella, Joe; Epstein, Edward Z.; and Clark, Eleanor. *Those Great Movie Ads*. New York: Arlington House, 1972.

The New York Times Directory of Film. New York: Arno Press/Random House, 1971.

Price, Charles Matlock. *Poster Designers*. New York: George W. Bricka, 1922.

Rebello, Stephen, and Allen, Richard. *Reel Art*. New York: Abbeville, 1988.

Reed, Walt. *Great American Illustrators*. New York: Artabras/Crown, 1979.

Reed, Walt, and Reed, Roger. *The Illustrator in America 1900-1960*. New York: Reinhold, 1966.

Rhode, Eric. *A History of the Cinema*. New York: Hill and Wang, 1976.

Rosten, Leo. *Hollywood: The Movie Colony, the Movie Makers*. New York: Harcourt Brace, 1941.

Schapiro, Steve, and Chierichetti, David. *The Movie Poster Book*. New York: Dutton, 1979.

Schau, Michael. *All-American Girl: The Art of Coles Phillips*. New York: Watson-Guptill, 1975.

Schickel, Richard, and Hurlburt, Allen. *The Stars*. New York: Bonanza, 1962.

Symons, Arthur, and Harris, Bruce S. *The Collected Drawings of Aubrey Beardsley*. New York: Crescent, 1967.

Taylor, Deems. *A Pictorial History of the Movies*. New York: Simon & Schuster, 1943.

Taylor, John Russell. *The Hollywood Musical*. New York: McGraw-Hill, 1971.

Thomas, Lawrence B. *The MGM Years*. New York: Columbia House, 1972.

Thomas, Tony, and Solomon, Aubrey. *The Films of 20th Century-Fox*. New Jersey: Citadel, 1979.

Trent, Paul. *Those Fabulous Movie Years: The 30s*. Barre: Barre Publishing, 1975.

Vargas, Alberto, and Austin, Reid Stewart. *Vargas*. New York: Harmony/Crown, 1978.

Variety Movie Guide. New York: Prentice Hall, 1992.

Vermilye, Jerry. *The Films of the Thirties*. New York: Citadel/Carol, 1990.

Walker, John, ed. *Halliwell's Film Guide*. New York: HarperPerennial, 1994.

Wilson, Arthur, ed. *The Warner Bros. Golden Anniversary Book*. New York: Dell/Film and Venture Corp., 1973.

Index

Page numbers in *italics* refer to illustrations.

Abbott, Bud, 120, *120*

Addams Family, The (1991), 171

Adventures of Marco Polo, The (1938), 98, *98, 99,* 180

Advertising. *See* Motion picture advertising

Advertising in the Motion Picture (compilation volume), 47

After the Thin Man (1936), 78, *79,* 178

Aladdin (1992), 171

All That Jazz (1979), 168

Allyson, June, 110, 137

Along Came Jones (1945), 140, *141,* 180

Ameche, Don, 105, *105*

American magazine, 179

American Tragedy, An (1931), 180

Amsel, Richard, 169, 170

Anderson, Eddie "Rochester," 126

Annabella, 104, *104*

Anna Karenina (1935), 62, *63,* 178

Angel (1937), 177, *177*

Anna Christie (1930), 176

Apocalypse Now (1979), 168

Armstrong, Louis, 126

Arlen, Harold, 126

Arliss, George, 40, *41*

Around the World in 80 Days (1956), 165

Artists and Models (1937), 175

Astaire, Fred, 74, *75,* 102

Auer, Mischa, 94

Babes on Broadway (1941), *119,* 119

Bacall, Lauren, 157, *157*

Baer, Howard, *125,* 125, 175

Bagdad (1949), 160, *161*

Bagnold, Enid, 131

Baker, Carroll, 82

Barclay, McClelland, 175, *175*

Barrymore, Lionel, 157, *157*

Bass, Saul, 165–166, 167

Batman Returns (1992), 171

Baum, Vicki, 151

Baxter, Warner, 94, *94*

Beall, Cecil Calvert, 111, 144, *145,* 175

Beardsley, Aubrey, 23, *26,* 27 stylistic influence of, 27, 30, 33, 39

Beauty and the Beast (1991), 171

Becky Sharp (1935), 46, 84

Beery, Wallace, 58, *59*

Ben Hur (1926), 176

Ben-Hur (1959), 166

Benny, Jack, 68

Bennet, Joan, 94, *94*

Bergman, Ingrid, 154, *155,* 179

Berkeley, Busby, 114

Berkey, John, 169

Berlin, Irving, 102

Bessor, 166

Bey, Turhan, 160

Big Broadcast of 1938 (1937), 181

Big Clock, The (1948), 156, *156*

Biograph studio, 18

Birnbaum, Abe, 52, 88, *89,* 151, *151,* 176

Blackfoot, Thomas, 171

Blade Runner (1982), 170

Blind Husbands (1919), 28, *28*

Blonde Venus (1932), 66, 177

B'Nai B'Rith Cinema Lodge, 167

Bogart, Humphrey, 157, *157*

Boles, John, 50, *51*

Bonjour Tristesse (1958), 165–166

Born To Be Bad (1950), 184

Boyle, Neil, 166

Brackman, Robert, 152, *152,* 176

Brice, Fanny, 100

Bringing Up Father (1928), 178

Broadway Melody of 1936 (1935), 68, 69

Broadway Rose (1922), 35

Broken Bath, The (1910), 18, *19*

Bronco Billy (1980), 170

Brown, Reynold, 167

Burrows, Hal, 60, *61,* 68, 69, 101, *101,* 120, *120,* 131, *131*

Buttons, Red, 128

Cabaret (1972), 168

Cabin in the Sky (1943), 126, *127,* 178

Calloway, Cab, 126

Camelot (1967), 167

Camille (1936), 86, *86*

Capra, Frank, 148

Captain from Castile (1947), 150, 150

Cardinal, The (1963), 167

Carefree (1938), 102, 103

Carmen Jones (1955), 165

Carroll, John, 120

Champlin, Charles, 166

Chaplin, Charlie, 38, 38

Chaplin studio, 38

China Sky (1945), 175

Chorney, Steve, 171

Christianson, Dave, 171

Cimarron (1931), 56, 176

Citizen Kane (1941), 180

Clark, Benton, 176

Clift, Montgomery, 153

Cobb, Lee J., 128

Coburn, Robert, 147, 147

CoConis, Ted C., 169

Cocoon (1985), 170

Colbert, Claudette, 80, 148, 149

College Swing (1938), 181

Collier's magazine, 175, 179

Colman, Ronald, 80, 121, 121, 129, 129

Columbia Pictures, 134, 147

Cooper, Gary, 52, 53, 98, 98, 99, 140, 141

Cooper, Mario, 111

Corn Is Green, The (1945), 146, 146

Cosmopolitan magazine, 176, 179, 183

Costello, Lou, 120, 120

Cotton, William, 52, 53

Cover Girl (1944), 134, 135

Curtis, Tony, 160

Crawford, Joan, 52, 53, 88, 89

Crawford, William Galbraith, 58, 59, 176–177

Dancing Pirate, The (1936), 84, 84

Dancing Lady (1933), 88

Davis, Bette, 106, 107, 146, 146

Day, Laraine, 139, 139

Day at the Races, A (1937), 178

Day of Reckoning (1933), 56, 57

Day of the Locust, The (1975), 168

Deathtrap (1982), 171

DeFore, Don, 148, 149

Desert Gold (1919), 20, 21

Designing Women (1957), 179

Desmond, William studio, (1922), 34, 34

Devil Is a Woman, The (1935), 66, 66, 177

Diamond Horseshoe (1945), 144, 145, 175

Dick Tracy (1990), 171

Dietrich, Marlene, 66, 66, 129, 129, 177

Dietz, Howard, 131, 131

Dietz, James, 168–169

Dimples, 85, 85

Dinner at Eight (1933), 177

Disney studio, 46, 84, 93, 182

Disraeli (1929), 40, 41

Dix, Richard, 56

Douglas, Lloyd C., 70

Douglas, Melvyn, 123, 123

Down Argentine Way (1940), 113

Dragon Painter, The (1919), 24, 25

Drake, Tom, 132, 132

DuBarry Was a Lady (1943), 124, 124, 125, 125, 175, 181

Dumas fils, 86

Durante, Jimmy, 137, 137

Dyer, Rod, 167

Eagle's Nest, The (1907), 17

Easy to Love (1953), 82

Eddy, Nelson, 101, 101, 122, 122

Edison, Thomas Alva, 16–17

Egyptian, The (1954), 166

Elvin, John, 170, 171

Empire of the Sun (1987), 170

English, Mark, 169

Enos, Randall, 167

Erikson, Carl Oscar August ("Eric"), 177

Esquire magazine, 85, 116, 125, 175, 181, 182

Essanay studio, 18

E. T. The Extra Terrestrial (1982), 170

Everybody Sing (1938), 100, 100

Every Day's a Holiday (1937), 181

Excalibur (1981), 171

Exodus (1960), 167

"Fadeaway Girl," 29

Fairbanks, Douglas, 36, 37

Fairbanks studio, 36

Falkenberg, Jinx, 134, 134

Fan magazines, 111

Farrell, Charles, 49, 49

Faulkner, William, 52

Faye, Alice, 105, 105, 113

Fellini, Federico, 166

Ferber, Edna, 76, 90, 143

Fields, Dorothy, 67

First Year, The (1932), 49, 49

Flagg, James Montgomery, 111

Flame of New Orleans (1941), 182

Flato, Hans, 66, 66, 177, 177

Flower Drum Song (1961), 167

Flowers and Trees (1932), 46

Fly, The (1958), 166

Follow the Fleet (1936), 74, 75

Fonda, Henry, 67

Fontaine, Joan, 184

For Me and My Gal (1942), 177

Fox studio, 49, 50

Frazetta, Frank, 168

From Hell to Heaven (1933), 175

Funny Lady (1975), 168

Gable, Clark, 72, 73, 88, 89, 118, 118, 119

Garbo, Greta, 62, 63, 86, 86, 111

Gargink, 150, 150

Garland, Judy, 100, *100*, 110, 114, 119, *119*, 132, *132*, 133
Garson, Greer, 121, *121*
Gaynor, Janet, 49, *49*
General Film Company, 18
Gilda (1946), 147, *147*
Girl of the Golden West, The (1938), 101, *101*
Glass Slipper, The (1954), 183
Goddard, Paulette, 158
Gold Rush, The (1925), 38, *38*
Goldwyn studio, 32, 98, 99, 180, 182
Gone With the Wind (1939), 47
Gone With the Wind (1959 reissue), 166
Good Housekeeping magazine, 176, 181, 183
Gotham Productions, 39
Government Girl (1943), 175
Gozée, Dan, 170
Grable, Betty, 110, 113, 116, *117*, 134, 144, *145*
Grand Hotel (1932), 177
Grand Prix (1966), 167
Grayson, Kathryn, 120
Great Depression, 44
Great Train Robbery, The (1903), 17
Great Ziegfeld, The (1936), 114
Grey, Zane, 20
Grosz, Karoly, 70, *71*
Grot, Anton, 36, *37*, 177
Grove, David, 169
Guile of Women, The (1921), *32*

Hall, Jon, 160
Hammerstein, Oscar, II, 76
Harburg, E. Y., 126
Harlow, Jean, 60, *61*, 82, *83*
Harper's Bazaar magazine, 176, 183
Hart, Lorenz, 84, 122
Hart, Moss, 128

Hat Check Girl (1932), 50, *51*
Hatser, Fred, 166
Hawks, Howard, 153
Hayakawa, Sessue, 25
Hayes, Peter Lind, 128
Haymes, Dick, 144, *145*
Hayworth, Rita, 110, 134, *134*, 147, *147*
Heaven Can Wait (1978), 168
Heaven's Gate (1980), 170
Held, John, Jr., 23
Henie, Sonia, *92, 93*
Hepburn, Katharine, 123, *123*, 130
Her Jungle Love (1938), 96, 97
Hirschfeld, Albert, 52, 64, 65, 111, 126, *126*, 132, *132*, 177–178
Hitchcock, Alfred, 166
Hollywood Canteen (1944), 136, *136*
Hollywood Cavalcade (1939), 105, *105*
Honeymoon (1947), 151, *151*, 176
Honky Tonk (1941), 118, *118*, 119, 179
Hooks, M., 167
Horne, Lena, 126
Hotel for Women (1939), 175
Howard, Leslie, 87, *87*
Hunt, Marsha, 137, *137*

Ideal Husband, An (1948), 158, *159*
I Dream Too Much (1935), 67, *67*
Illustrators
 anonymity of, 46
 specialization of, 45
 See also Motion picture advertising
I Married an Angel (1942), 122, *122*
"In a Position to Know" (Phillips), 29
Ince, Thomas, 25
Independent Motion Picture

Company of America (IMP), 18, 30
Indiana Jones and the Temple of Doom (1984), 171
Inn of the Sixth Happiness, The (1958), 166
Intermezzo (1939), 179
International studio, 160
Ireland, Ted ("Vincentini"), 62, *63*, 78, *79*, 82, *83*, 86, *86*, 87, *87*, 100, *100*, 101, *101*, 111, 178
Isep, *92, 93*
It Happened One Night (1934), 148
It's a Mad Mad Mad Mad World (1963), 167
Iturbi, Jose, 137, *137*
I Wanted Wings (1941), 175

Jaedicker, Herbert, 94, *94*, 98, *98*
Jaedicker, Theodore, 104, *104*
Joan of Arc (1948), 154, *155*
Johnny Eager (1942), 119, *119*
Johnson, Doug, 169
Johnson, Van, 82
Jones, Allan, 100
Jones, Jennifer, 110, 152, *152*
Juarez (1930), 106, *107*
Jungle Fever (1991), 171
Jungle Princess (1936), 96

Kahn, Gus, 101
Kalem studio, 18
Kapralik, Jacques, 52, 118–123, 133, 137, 139, *139*, 166, 178–179, *178*
Kaufman, George S., 90
Keep Your Powder Dry (1945), 139, *139*
Kern, Jerome, 67, 76
Kerness, Jack, 134
Key Largo (1948), 157, *157*
Kinetoscope, 16
King, Dennis, 122

Kingman, Dong, 167
Kipling, Rudyard, 31
Kismet (1944), 129, *129*
Knight Without Armour (1937), 177
Korda studio, 158

Ladies They Talk About (1933), 182, *182*
Lagatta, John, 179, *179*
Lamarr, Hedy, 111, 114
Lamour, Dorothy, 96, *97*
Lederer, Francis, 77, *77*
Laemmle, Carl, 18, 19
Lake, Veronica, 110
Last Train from Gun Hill (1959), 166
Latham, Woodville, 17
Laughton, Charles, 72, *73*, 156, *156*
Lawrence, Florence, 18, 19
Leave Her to Heaven (1945), 142, *142*
Lee, Robert C., 98, *98*
Leslie, Joan, 110
Lettick, Bernie, 169
Libeled Lady (1936), 82, *83*, 178
Life magazine, 134
Line art, 22
Lincoln, Elmo, 20, *21*
Lion King, The (1994), 171
Logan's Run (1976), 168
Louis, Jean, 147
Louis B. Mayer studio, 25
Love on the Run (1936), 88, *89*, 176
Loy, Myrna, 39, 78, *79*, 82, *83*
Lubin studio, 18
Luders, Alex, 49, *49*
Lupino, Ida, 77, *77*

McCallister, Lon, 128
McCall's magazine, 176
McLean, Wilson, 168

McLeod, Ronald, 179
MacDonald, Jeanette, 101, *101*, 122, *122*
McLaglen, Victor, 80, *81*
McLeod, Ronald, 94, *94*
Madame Peacock (1920), 30, *30*
Madison, Guy, 151, *151*
Magazines
 as entertainment source, 22
 fan, 111
 illustrators for, used by movie industry, 45
Magnificent Obsession (1935), 70, *71*
Manhattan (1979), 168
Man With the Golden Arm, The (1956), 165
Markman, Ken, 169
Martin, Tony, 82
Marx Brothers, 64, *65*
Mayer, Louis B. studio, 25
Meet Me in St. Louis (1944), 132, *132*, 133, *133*, 178
Melies studio, 18
Metro-Goldwyn-Mayer (MGM), 47, 52, 56, 58, 64, 68, 72, 78, 82, 86, 87, 88, 100, 101, 114, 118–126, 129–133, 137, 139, 176, 177, 180, 181
Metro Pictures Corporation, 35
Metropolitan Museum of Art, 152
Milland, Ray, 96, *97*, 156, *156*
Min and Bill (1930), 178
Mind the Paint Girl (1919), 25, *25*
The Missouri Breaks (1976), 168
Montez, Maria, 160
Moon Over Miami (1941), 116, *117*, 134, 182
Moore, Grace, 67
Motion picture advertising
 art department specialization in, 45
 awards for, 167

color used extensively in, 46–47
compilation volume on, 47
coordinated with various media, 47–48, 168
early attempts at, 22
experimental techniques in, 48
freelance artists increasingly used in, 169
1950s approach to, 165–166
1960s approach to, 166–167
1970s approach to, 167–169
1980s approach to, 169–171
1990s approach to, 171
photography increasingly used in, 166–167, 171
professionalism of, 23
stylistic trends of, 23
technical advances in, 167
Motion picture industry
 antitrust laws and, 165
 color first used in, 46–47, 84
 corporate identity in, 47, 112, 136, 143
 escapism and, 111
 radio competes with, 44
 sound first used in, 44
 television competes with, 165
 World War II and, 110, 112, 138, 139, 175, 184
Motion Picture News, 19
Moulin Rouge (1952), 183
Movita, 72, *73*
Mowbray, Alan, 94
Muni, Paul, 106, *107*
Murray, Mae, 35, *35*
Music for Millions (1944), 137, *137*
Mutiny on the Bounty (1935), 72, *73*, 177
Myers, Jack, 134
My Fair Lady (1964), 167

Nana (1934), 182
Nathan, Robert, 152

National Velvet (1944), 130, *130*, 131, *131*
Naughty Marieta (1935), 177
Nazimova, Alla, 30, *30*
Nelson, Barry, 128
New Yorker magazine, 175, 176
Night at the Opera, A (1935), 64, 65, 178
No No Nanette (1940), 175
Normand, Mabel, 105
North by Northwest (1959), 166
Novak, Jerome, 113, *113*

O'Brien, Edmond, 128
O'Brien, Margaret, 132, *132*, 133, 137, *137*
O'Hara, Maureen, *161*
One Rainy Afternoon (1936), 77, 77
Outlaw, The (1943), 184, *184*

Paramount Pictures, 54, 66, 96, 156, 175, 178, 179, 180, 181, 182
Pathé studio, 18, 20, 31
"Peacock Skirt, The" (Beardsley), 27
Peak, Robert, 167, 168, 170
Perils of the Yukon (1922), 34, *34*
Peters, Jean, 150, 150
Peters, Susan, 139, *139*
Petty, George, 23, 116, 182
Phillips, Coles, 23, 27, 29, *29*
 stylistic influence of, 23, 27, 50, 60
Photoplay magazine, 111
Pictorial Review, 179
Pigeon, Walter, 39
Pin-Up Girl (1944), 134
Pioneer Pictures, 84
Pons, Lily, 67, *67*
Porter, Cole, 124
Portrait of Jennie (1948), 152, *152*, 176

Poseidon Adventure, The (1972), 168
Powell, Eleanor, 68
Powell, William, 60, *61*, 78, *79*, 82, *83*
Power, Tyrone, *92*, 93, 104, *104*, 150, *150*
Preferred Pictures, 33
Psycho (1960), 167
Purple Heart, The (1944), 138, *138*, 181

Radio, competition from, 44
Raiders of the Lost Ark (1981), 171
Raiidall, 28
Rainer, Louise, 114
Rainman (1988), 170
Random Harvest (1942), 121, *121*, 179
Razor's Edge, The (1946), 140, 180
Reckless (1935), 60, *61*
Record, Don, 167
Red Dust (1932), 177
Red River (1948), 153, *153*
Reiss, Lionel S., 32, *32*, 180
Reynolds, Joyce, 110
Rich Men's Wives (1922), 33, *33*
Rio Rita (1942), 120, *120*
RKO, 67, 74, 90, 95, 102, 148, 151, 154, 165, 175, 176, 180
RKO Radio, 84
Robin Hood (1922), 177
Robinson, Edward G., 157, *157*
Rocketeer, The (1991), 17
Rockwell, Norman, 99, *99*, 111, 140, *141*, 167, 180
Rodgers, Richard, 84, 122
Rogers, Ginger, 74, *75*, 95, *95*, 102
Rogers, Will, 32, *32*
Rollerball (1977), 168
Romberg, Sigmund, 101
Romeo and Juliet (1936), 87, *87*, 178

Rooney, Mickey, 119, *119*
Rose, William, 95, *95*, 180
Rubin, Hy, 70, *71*, 181
Russell, Gail, 110
Russell, Jane, 110, 184, *184*
Russell, Rosalind, 80, *80*
Ruyssen, Roger, 170

Sabrina (1994), 171
Sabu, 160
Salk, Laurence, 168
Salome, 27
Saratoga Trunk (1945), 143, *143*
Saturday Evening Post, 140, 176, 180
Sayonara (1957), 183
Scarlet Empress, The (1934), 177
Schlaifer, Charles, 113, *113*, 116, 117
Seconds (1966), 167
Seguso, Armando, 111
Selig studio, 18
Seltzer, Isadore, 169
Selznick studio, 152
Sennett, Mack, 105
Seurat, Georges, 36
Seven Year Itch (1955), 165
Shakespeare, William, 87
Shanfield, Louis, 104, *104*
Shannon, Peggy, 50, *51*
Shearer, Norma, 87, *87*, 123, 123
She Done Him Wrong (1933), 54, 55
Sheridan, Ann, 110
Sheriff, Paul, 183
Shermund, Barbara, 125, *125*, 181
Shimin, Symeon, 124, *124*, 181
Show Boat (1936), 76, *76*
Siebel, Frederick ("Fritz"), 138, *138*, 181
Silence of the Lambs (1991), 171
Silk Stockings (1957), 166, 179
Smith, Emmett O., 31, *31*, 182
Snow White and the Seven Dwarfs (1937), 48, 93, *93*, 182

Song of Bernadette, The (1943), 140, 180

Sound, early motion picture use of, 44

Spartacus (1960), 167

Spear, Adrian Gill, 36, *37*

Stagecoach (1966), 167

Stage Door (1937), 90, *91*

Star Trek II: The Wrath of Khan (1982), 171

Stewart, Anita, *25*

Stewart, James, 95, *95*, 114

Streuzan, Drew, 170, 171

Stroheim, Erich von, 28, *28*

Strumf, David L., 67, *67*, 102, *103*, 148, *149*

Stuntman, The (1980), 170

Suddenly It's Spring (1946), 182

Suez (1938), 104, *104*

Superior Pictures, 25

Superman (1978), 168

Suspicion (1941), 180

Sweethearts (1938), 47

Talkies. *See* Sound

Tall in the Saddle (1944), 176

Tannenbaum, Robert, 167

Tattoo (1980), 170

Taylor, Don, 128

Taylor, Elizabeth, 130, *130*

Taylor, Robert, 68, 86, *86*, 119, *119*

Teahouse of the August Moon (1956), 179

Technicolor, 46-47, 84, 94, 96, 105, 113, 129, 132, 142, 150, 154, 158

Television, competition from, 165

Temple, Shirley, 85, *85*, 151, *151*

Tenggren, Gustaf, 93, *93*, 182

Thief of Bagdad, The (1924), 36, *37*, 177

Thin Ice (1937), *92*, 93

Thin Man, The (1934), 177

Tierney, Gene, 142, *142*

Tin Pan Alley (1940), 113, *113*

Today We Live (1933), 52, *53*

Tolstoy, Leo, 62

Tomaso, Rico, 104, *104*

Tracy, Spencer, 82, *83*, 123, *123*

Trail of the Lonesome Pine (1936), 180

Trevor, Claire, 157, *157*

Trip to the Moon, A (1902), 17

Turn Back the Hours (1928), 39, *39*

Turner, Lana, 110, 114, 118, *118*, 119, *119*, 139, *139*

Twentieth Century-Fox, 80, 85, 93, 104, 105, 112, 113, 116, 128, 138, 142, 144, 150, 158, 175, 178, 181, 182

Under Two Flags (1936), 80, *80, 81*

United Artists, 77, 94, 98, 99, 140, 153, 179

Universal Pictures, 28, 34, 70, 76, 160, 182

Unruh, Jack Neal, 169

Vanguard Pictures, 151

Vargas, Alberto, 23, 46, *85*, 85, 111, 116, *117*, 125, *125*, 182

Vertès, Marcel, 158, *159*, 183

Vertigo (1958), 165

Victor/Victoria (1982), 170

Villa, Pancho, 58

Vincentini. *See* Ireland, Ted

Vinson, Helen, 94

Vivacious Lady (1938), 95, *95*, 180

Viva Villa! (1934), 58, *59*

Vitagraph studio, 18

Vogue magazine, 183

Vogues of 1938 (1937), 94, *94*, 179

Walk on the Wild Side (1962), 167

Wanger studio, 94

Warner Bros., 40, 106, 112, 136, 143, 146, 157, 177, 178, 182

Waters, Ethel, 126

Wayne, John, 148, *149*, 153

West, Mae, 54, 55

Weston, Harry Alan, 34, *34*, 183

West Side Story (1961), 167

We Were Dancing (1942), 123, *123*

Whitcomb, Jon, 166, 183

Wicks, Ren, 166, 184, *184*

Widhoff, 74, *75*

Widow Jones, The (1890s Kinetoscope), 17

Wilde, Cornell, 142, *142*

Wilde, Oscar, 158

Williams, Esther, 82, 110

Winged Victory (1944), 128, *128*

Without Benefit of Clergy (1921), 31, *31*

Without Reservations (1946), 148, *149*

Wizard of Oz (1939), 47

Woman of the Year (1942), 123, *123*, 179

Women, The (1939), 178

World War II, 110, 112, 138, 139, 175, 184

Wray, Fay, 58, 59

Young, Loretta, 104, *104*

Young, Tom, 168

Zanuck, Darryl F., 128

Ziegfeld, Florenz, 114

Ziegfeld Follies, 32, 35, 114, 182

Ziegfeld Girl (1941), 114, *115*

Zorina, Vera, 122